T0249139

Unlocking

Unlocking

A MEMOIR OF
FAMILY AND ART

Nancy L. Pressly

SHE WRITES PRESS

Published 2020
Printed in the United States of America
ISBN: 978-1-63152-862-0
ISBN: 978-1-63152-863-7
Library of Congress Control Number: 2019920711

For information, address:
She Writes Press
1569 Solano Ave #546
Berkeley, CA 94707

Interior design by Tabitha Lahr

She Writes Press is a division of SparkPoint Studio, LLC.

For Bill
with love

Contents

PART THREE
Enduring Hearts

PART ONE

The Power of the Image to
Unlock Memories

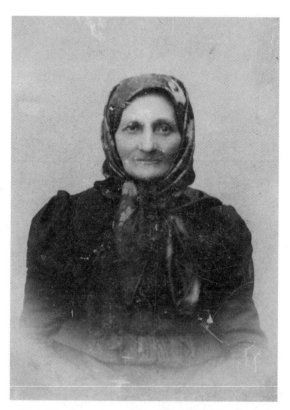

*Visit Visa photo, possibly Grandpa Freedman's
mother from Latvia*

1. Opening Doors to the Past

I t was a chilly winter day, but the third-floor room was filled with sunlight, unexpectedly comfortable. I opened the low door that led into our attic and half stooped, half crawled inside, adjusting my eyes to the shadowy space. Beams of light from a small window revealed boxes of research files and books, bags of discarded toys, suitcases stuffed with old, forgotten clothes, and empty picture frames scattered about. I found the boxes I was looking for stacked near the door, six in all, some carefully sealed, others half-open, the ones lower down crumpling from the weight of the boxes above. They contained my mother's and father's histories, everything from bank deposit slips going back thirty years to passports and report cards and hundreds of old photographs, and what seemed like every letter ever written by my parents or sent to them by my brother and me. It had been so long since I'd even thought about what was inside.

I pulled the boxes out of the attic one by one and randomly spread some of the contents onto the carpeted floor around me. I found my maternal grandfather's citizenship certificate, dated 1902 and stamped with a large red seal, and the original naturalization papers for my father and his family, yellowed and stained, signed in brown ink and boldly dated 1914. There was a haunting image of a middle-aged Russian woman, her hair covered by a babushka-like

scarf—surely an unknown relative—and, in stark contrast, a New York studio photograph circa 1900–1905 of an elegantly dressed young woman wearing a stylish, large-brimmed hat topped with lace and plumage; I discovered only later this was probably my maternal grandmother. I looked at early photographs of my mother, age two or three, shyly leaning against her mother. As I dug a little deeper into the first box, I uncovered my parents' marriage certificate, dried flowers from my mother's bridal bouquet, and their honeymoon itinerary in its original blue folder, along with a wedding photograph which I had never seen. I took a deep breath.

My first instinct had been to sort through the boxes quickly, organizing the family material by general categories in archival-quality boxes and preserving them. But now, in the quiet of that room in our home of twenty-five years in Washington, DC, I started to look at the photographs more closely. I was astonished at the power of the image to move me, to unlock memories, to tell stories. I held in my hand an image of a thirteen-year-old boy wearing his bar mitzvah tallit and dressed in what were clearly homemade clothes. At first, I thought it was my father, but then, comparing it with other photographs, I realized it could only be his beloved brother, Max, who died in his teens. This was the first time I had seen pictures of Max. My father had never shown them to me. There were also several images of my father's parents in a New York photographer's studio, dressed in their very best clothes, standing in front of fanciful backdrops. They were posing for photographs that undoubtedly cost them money they could ill afford, but they wanted to capture themselves, to freeze this moment in time. I was haunted by their faces, especially my grandmother looking so youthful, and by what I didn't know about them and the lives they had lived. And then, suddenly, by what I didn't know about my own parents, how little I had asked them, especially my father, when they were alive, and how little my son and grandchildren in the future might know about me.

A year before, in 2006, at the age of sixty-five, I was diagnosed with ampullary cancer and survived the Whipple procedure, one

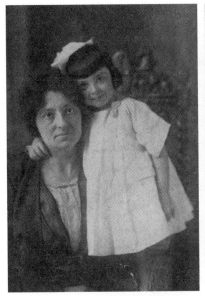

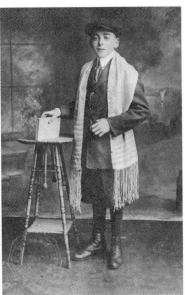

Mother and Grandma Bessie *Max, age 13*

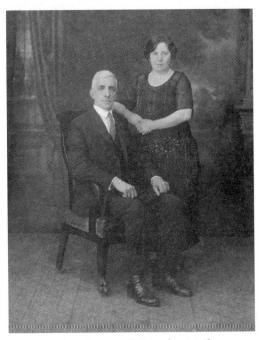

Grandma Rose and Grandpa Nathan

of the most complicated and difficult of operations and the only possible cure for pancreatic-related cancer. After the procedure I was given a 50 percent chance of survival. In the months that followed the end of subsequent radiation and chemotherapy, as I slowly recovered, I lived in suspended time. I tried diligently and probably sometimes desperately to bring order to my life and my home. Starting in the kitchen, drawers and cabinets were straightened and bags of broken utensils and old pots and dishes were thrown away. I moved on to bedroom closets and dresser drawers, discarding clothes that no longer fit, and then to my office, where cabinet files were emptied and client reports were neatly arranged on shelves. I was finally ready to move on to the more difficult things: the boxes in the attic.

I became obsessed, spending hours at a time in that third-floor room, looking closely at every photograph and document. I remembered as a child watching my grandfather sitting at the dining room table, pasting some family photographs into an album. Now I removed them from the poor paper they were attached to and looked at them as if for the first time. I could identify many of the people but by no means all of them. I am an art historian, trained to discern visual clues and decipher meaning. Now, as I looked carefully at photographs of my father in his youth, I tried to fathom his life as a young man. He had wonderfully thick hair, sometimes parted in the middle, and occasionally wore pince-nez glasses.

In studio photographs he is always in a suit and tie, very serious, and posing in a way that suggests how he looked was a matter of importance to him. There were also snapshots from the 1920s showing him smiling and cheerful among friends, projecting a sense of joie de vivre and self-confidence. I stared at these photos because I never thought about him in this way. By the time I was born, my father was forty-five.

Looking at these photographs of my father stirred deep emotions that had been blocked for decades, lost in the amnesia and trauma of my teenage years and my difficult and unresolved

relationship with him. As I studied my father's likeness, I realized I had a responsibility to preserve his memory into the future, or it would be lost forever. I was the only one alive who could do this. He had lived a life just as I had lived, filled with hard work, love, pain, good times, guilt, travel, opera, and sleepless nights. He was emotional and introspective, and he felt life deeply. My recent illness had brought home to me my own mortality, and the sense of passing history on to the next generation was not theoretical but now very real. I needed to find a way to pass my parents' stories on to my son and grandchildren and my brother's son and daughter and their children, so it could have some meaning for them when I am no longer here.

I had never really thought very much about the context of my parents' lives before they met and had almost no historical information, just snippets of stories my father or mother may have told me. Fortunately, I had asked my mother some questions in the years before she died. Although by then, in her late eighties, she had already begun to lose her memory, the information would prove helpful as I undertook the task of creating a basic narrative about my family. My first step was to gather as much information as I could from the material I had sorted. Then using my professional skills as a scholar, I researched web-based genealogical sources and East European Jewish archival sites, returning to them again and again as new materials were added. I scrutinized ship logs and immigration and naturalization records and census data, linking family members who emigrated from the same area over several years. I also uncovered vital marriage, birth, and death records in New York State archives that provided information such as apartment addresses, and, from online digital marriage records from a small synagogue in Canada, I was able to confirm my paternal grandmother's maiden name.

Because family information tends to get divided among family members over generations, my next step was to track down distant relatives, many of whom I had never met. I was rewarded with early photographs from disparate sources, including faded images of my

paternal grandparents' siblings and half-siblings, whom I had not even known existed. The information I retrieved was fascinating and sometimes revelatory, and I was able to trace both lines of the family back to the "old country." From these records, various scraps of information, and photographs, I was able to weave together an outline of my grandparents' lives and of my parents in their youth. Some details have obviously been left to conjecture. In the process, it dawned on me, remarkably for the very first time, that on my father's side, at least, I was a first-generation American. I was astonished at what little interest I had felt until now to learn more about life in Eastern European Jewish shtetels and what it meant to flee persecution and pogroms in the early twentieth century.

My paternal grandmother, Rose Maidenberg, born in 1878, came from a rabbinical family, possibly Rabbi Ben-Zion Gersh Midenberg who died in 1905, from the town of Shorgorad in an area known as Podolia, then part of the Russian Empire. Rose's mother died very young, probably in childbirth, and Rose deeply resented her new stepmother, with whom her father had at least three additional children.

Promised to Nathan Dorfman when she was thirteen, Rose married at sixteen. This was not a love match, and she always looked down on her husband, my grandfather, who was nonetheless a kindly man. My father, Herman Irwin, was born in 1896, probably in Verbovets, twenty miles from Shorgorad, and close to the River Dniester. By 1918 this area had become part of Romania and today is in Western Ukraine. He had told me that his chest and spine were somewhat deformed because he had been wrapped like a mummy as a baby. I had no idea what this meant until I read that the prevailing custom in this area was to bind babies for months at a time in four-inch bands of swaddling from the neck to their feet, with their hands twisted in the back!

Rose's half-sister, Sarah Maidenberg, married Samuel Akerboymn and, by 1905, was living in Sekurani, twenty miles from Verbovets. (Samuel's father's gravestone still stands in the town's

overgrown old Jewish Cemetery.) In a circa 1912 photograph with her husband and children in Sekurani, Sarah is wearing a distinctive necklace, and being intensely visual I recognized immediately that this was the same necklace worn by a young woman in a small locket-size photograph that I had discovered in the boxes. Rose most likely took this image with her to America. Rose and Sarah, who bore a striking resemblance to one another, stayed connected. In 1922 Sarah's son, Eddie, immigrated to New York and lived for a time with Rose and Nathan in Brooklyn.

I also uncovered an extraordinary memoir written by a young man who lived in Sarah's village and immigrated to New York in 1905, the same year as my father. For the first time, my father's early life became tangible to me: this memoir opens a window onto the daily lives of the Jewish community in this region, comprised mainly of merchants, shopkeepers, and skilled trade people, such as tailors, who often lived above their shops. Jews lived in a segregated portion of town and went to Jewish schools. The community placed a high value on education, and boys were taught to read Hebrew at age three and, once fluent, would begin to study the Talmud. My father would have almost certainly had a rigorous education before he left Russia. The small towns in this region were not isolated, and people enjoyed traveling theater groups and itinerant entertainers as well as visiting cantors who gave concerts. A major cultural center, Kamyanets-Podilsky, was also in the area.

The Dorfman family story was typical of East European Jewish families fleeing discriminatory laws and the threat of pogroms at the turn of the century. My grandfather Dorfman, as was the custom, immigrated first to New York circa 1898, probably with one of his brothers, and a couple of years later paid passage for another brother, Motel (Max), who arrived ill in 1900 and was detained. Nathan eventually earned enough money to secure passage for Rose and their two children, my father, "Hyman," age nine, and Esther Ruth or "Esse," age eight, as well as for Riwke Kimmelman, an eighteen-year-old sister-in-law of one of Nathan's half-brothers.

Rose, who could read and write Hebrew and Yiddish, was at first reluctant to leave Podilia, but she eventually acquiesced, departing just months before pogroms terrified the Jewish community throughout Bessarabia. She was probably accompanied by other extended family members; my father recalled great drama and wailing as the family separated, with some going to Palestine and others to South America, knowing they would never see each other again. Fleeing Jews, many without passports, would cross the Russian border and then travel on crowded trains along well-established routes to Germany or Holland, helped by people supported by Jewish relief organizations and by special ship agents posted along the way.

My father and his family eventually arrived in Rotterdam, their port of departure, where they would have been quarantined at the NASM Hotel, owned and exclusively used by the Holland America Line. There they would have been subject to numerous health inspections before finally boarding their ship, the three-year-old *Noordam,* which sailed from Rotterdam on July 29, 1905. Steerage-class passengers were mainly confined to large dormitory rooms, some apparently big enough to hold as many as three hundred people. Water and food would have been scarce, a fact not lost on first-class passengers who threw oranges and food down to Herman and Esse.

The family arrived in New York at Ellis Island on August 8, 1905. It is hard for me to fathom just how traumatic this journey had to be for Herman and Esse. Having passed through immigration, they waited in fenced-in holding areas designated by the first letter of their last name. There, Esse and Herman would have been greeted by their father, of whom they probably had almost no memory, and then were immediately immersed in the crowded and turbulent world of Jewish immigrants in the Lower East Side, where Nathan lived at 187 East Second Street. The family moved to Brooklyn sometime before Rose gave birth to her third child, Max, on June 15, 1906.

Nathan worked long hours in a mattress factory, and over the next two decades the family rented at least nine different apartments in Brooklyn. Herman and Esse would have begun school and learned English soon after their arrival, and neither had any trace of an accent as adults. They are proudly captured in a studio photograph celebrating their graduation, circa 1911–12, each holding a diploma, Herman dressed in a homemade suit with knicker pants and Esse in a white dress and white boots.

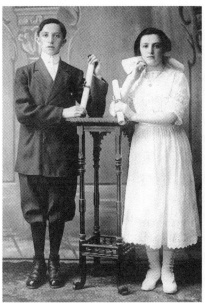 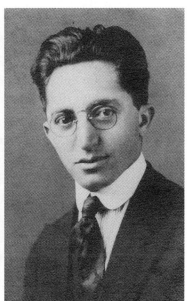

Esse and Dad *Dad, 1920s*

Herman also posed with his all-male graduating class, an interesting period document showing both the multinational demographics of immigrant children and the age disparity among the boys—as much as ten years. They are all dressed in suits, wearing white ties and boutonnieres in their lapels, each holding a diploma in their right hand as their distinguished-looking teacher sits amongst them.

My father and Aunt Esse never talked about their childhood years, or what it was like living in the crowded tenement buildings

in Brooklyn and moving every couple of years. They enjoyed some sense of an extended family as Nathan had at least two brothers and several cousins also living in New York, and Herman and Esse spent time in their late teens with Louis Dorfman (1883–1945), an uncle or cousin, and his family in Waterbury, Connecticut. They were also close to Meyer Dorfman, a cousin who emigrated about the same time and lived in Manhattan.

By 1915 Esse was working as a stenographer and Herman as a salesman. In 1918 Herman was assigned to the US Naval Aircraft Factory at Philadelphia Naval Yard. Although he never received a high school diploma—he left school to help support the family—Herman would graduate from the Cooper Union School of Engineering in 1921 with a BS in Civil Engineering and later receive a CE from Cooper Union in 1931, something he was immensely proud of. His brother, Max, a handsome and sensitive-looking child with a mischievous smile, had his bar mitzvah in 1919. Tragically, he contracted rheumatic fever soon after and died on April 20, 1921, leaving the family devastated. He was buried in the Society Berd Relief section of Mount Judah Cemetery in Queens, and Rose remained in deep mourning for the rest of her life. Fifteen years later, to the horror of her daughter-in-law, my mother, Rose was still walking round the house holding Max's photograph and crying out his name.

Brooklyn by 1920 had become a center of arts and culture, and as young adults Esse and Herman would have been exposed to the latest in movies and music as well as the intellectual activity of the Jewish cultural scene, not only in Brooklyn but also in Manhattan. Herman had an early interest in the opera and often repeated the story of how he got a ticket for the standing room section of the Metropolitan Opera to hear Enrico Caruso. This had to be before December of 1920, when Caruso last sang at the Metropolitan Opera House.

In 1924, Herman began work for the New York State Department of Public Works, a respected and secure job at the time. Probably around this time he acquired a Model T Ford car, which he named Lizzie, possibly after a girlfriend. "Lizzie" appears in several

snapshots, in which my father, among friends, is clearly enjoying his youth. Esse met her future husband, David Raffelock, in 1924; they married the following year and moved to Denver, Colorado, where David ran a writer's group and they created an interesting life for themselves. Esse, always a stylish dresser, was a force to be reckoned with, sometimes reinventing her past to make it more glamorous. I don't think Herman, however, ever forgot how far he had to travel to enjoy financial security.

Herman married Bertha Juceam in 1927. This was a short-lived union and they were divorced by January of 1930, after Bertha was purportedly unfaithful with his half-cousin. Adultery was a legitimate reason for divorce in the Jewish orthodox religion. By early 1930, Herman was living in Nanuet, New York, a small hamlet in Rockland County, some twenty-five miles from Manhattan, where he oversaw several New York State highway projects. He purchased a house, built circa 1900, and moved it a couple of hundred feet away from the road he was building. This house is where I grew up.

My mother, Martha Freedman, had a very different childhood, growing up initially in a well-to-do Manhattan family, the only daughter and youngest of three children. Her father, Louis Freedman, born in Dvinsk (now Daugavpils), Latvia in 1863, was probably the son of Eliezer Freedman, born ca. 1829 and registered in 1845 in the town of Jelgva. Louis was well educated, fluent in Russian and Hebrew, and skilled enough in math to be the assistant to a captain in the commissary of the Russian army, a highly unusual position for a Jewish man at the time. In a remarkably sharp studio photo from 1890, Louis is shown in uniform wearing a hat decorated with the insignia of the Imperial Russian Army; another photo depicts his captain. They were taken in the city of Kalouga, located one hundred and fifty miles southwest of Moscow. Louis immigrated to New York circa 1890–91 on the ship *Egypt* with two of his brothers, Joseph and Albert; their sister, Mary, joined them two years later.

Louis became a successful furrier in Manhattan and in 1903 met Bessie Theodore at her parents' restaurant in the West Village,

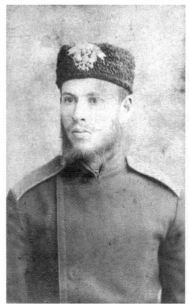
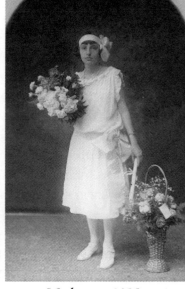

Grandpa Freedman *Mother, ca. 1928*
in Russian army

either on Wooster Street or West Houston Street, where they lived.
Seventeen years her elder, Louis married Bessie in 1904, with the
civil portion of the marriage performed, for some unknown reason,
by a minister. Bessie had arrived in New York in 1888 at age two with
her parents, Abraham and Yetta, from Vienna. The family eventually
included four girls and four boys, so as a young child Martha would
have been surrounded by a large family of cousins.

Martha grew up in relative luxury until she was about fifteen,
living on Lexington Avenue and later in a brownstone at 327 West
Twenty-Eighth Street, near her father's business, Louis Freedman
& Co., at 157 West Twenty-Seventh Street. Her father was wealthy
enough to own a Pierce-Arrow, one of the fancier cars of the day.
The Freedman children were photographed professionally on several
occasions; a circa 1918 photograph shows them stylishly dressed,
posed in front of their brownstone. Another depicts Martha on her
pony, Blackie, in front of the same brownstone. Martha graduated

in 1924 from P.S. 167, an imposing new school in Brooklyn; in her graduation photo, she wears a stylish white silk graduation dress and fancy shoes. A pretty girl, although by no means beautiful, she looks graceful and sensitive, but also dutiful and self-contained.

At least once a year Louis sailed to Latvia and other places in Europe for six to eight weeks to acquire furs, eventually wealthy enough to travel first-class on some of the major ocean liners of his day, including the *Mauretania*. He enjoyed the sophistication and luxury that came with that experience and dressed in suits and evening apparel made by his brother, an excellent tailor living in Massachusetts. An image with his eldest son, Leon, shows him a handsome man, in a morning suit with tails. Louis remained in touch with his three siblings, and photographs of them reveal a refined family I didn't know existed until now. In the mid-1920s, Louis bought a summer home with some forty acres in Nanuet, New York. Freedman Avenue in Nanuet is named for him.

Louis lost his money in the fur market crash in the late 1920s, and the family moved permanently to their country home in Nanuet, leaving New York City and their apartment in a new building near the Hudson River and the Little Red Lighthouse in Fort Washington Park, which my mother often talked about. To help support the family, Bessie turned their large wood-frame home into a boarding house and restaurant, which they called the Dew Drop Inn. Despite changed circumstances, family educational aspirations remained high. Martha's younger brother, Emil, went to the Free Academy, which later became the College of the City of New York, and brother Leon graduated from Columbia University in 1928, becoming a lawyer. Martha finished high school in nearby Spring Valley and then went to Hunter College in Manhattan, commuting by train but using Leon's New York apartment address as her "official" place of residence so she didn't have to pay tuition. After two years, she had to stop because she couldn't afford the train fare from Nanuet. Eventually Martha earned enough money as a salesclerk to finish her degree at Hunter College at Borough Hall Annex (later

Brooklyn College). She studied drama in college, which she loved, but trained to be a lab technician. This was not a finishing school education. Martha was prepared to work.

Herman Dorfman would occasionally eat at the Dew Drop Inn restaurant, where Martha waited on tables, and it was here that they met, repeating the story of her father meeting her mother some thirty years earlier. Martha was only nineteen, and Herman was recently divorced and thirty-five. They began dating two years later, in 1932, and were married in 1934 in a simple wedding ceremony in Newark, New Jersey, witnessed by her brother Leon and her first cousin Jeanette Dennis. They sailed to Newport Beach in Virginia for their honeymoon, where they spent several days at the elegant ocean-front Hotel Cavalier in Virginia Beach, a fashionable destination that opened in 1927. On their return, they began their life together in the home my father purchased in 1930. This was the context of my parents' lives before they met and what they brought to the table when they married. I had never pieced together this narrative before, and I was startled to realize the degree to which my parents were children of New York City. They embraced culture and intellectual pursuits and understood the energy and excitement of New York. Despite having few resources, they never abandoned these roots. They both had a certain refinement and taste that I didn't associate as a teen-ager with the stereotypical Jewish families of the time. They shared a cultural sophistication as well as the deeply rooted belief in the value of education, which was very much part of their life together. They would read poetry to one another by the fire. I grew up in a small town, which I would later like to refer to disparagingly as Hicktown USA. In compiling this brief history, it struck me for the first time that there was a reason I was later thought of as a sophisticated and cultured young woman. I didn't do it all on my own.

This was as far as I could go with my parents' stories. I was only eighteen months into recovery and was in no way ready to think more deeply about their lives, and in particular my childhood.

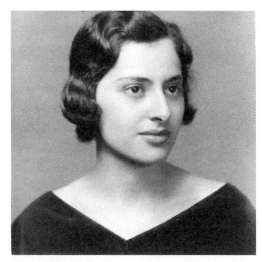

Mother ca. 1934

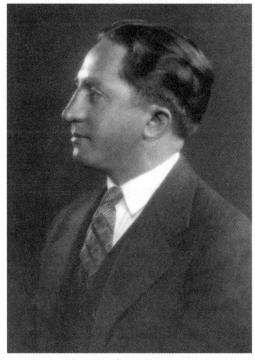

Dad ca. 1934

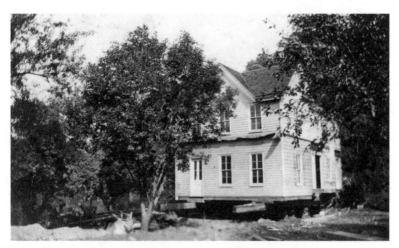

Our house ca. 1930

2. A Sense of Place

I was standing on our screened porch, watching our grandchildren play badminton in the yard, my favorite game as a child. Hummingbirds were diving at each other, fighting over the feeder, while our cinnamon-colored cat, Thomas, who had recently adopted us, slept peacefully curled on a chair. It was a gorgeous late afternoon. Now several years beyond my successful recovery, I was immersed in mothering again, having begun helping my son take care of his two beautiful children in 2009, when they were just one and three. My husband and I live in Atlanta, a block away from our son, having moved here from Washington, DC, in 2012.

The idea of writing a memoir, incorporating my parents' stories, had been percolating for some time. Caring for my grandchildren, loving them and providing a safe harbor, has made me think about my own childhood and how what we do and say as grandparents and parents, even random conversations, can linger and profoundly shape what each of us brings forward into our adult lives. At some point in my life, I had closed off and repressed much of my early memories and the family dynamics that shaped me. It was time to summon the courage and open, again, some of those carefully sealed boxes now stored in our guest room in Atlanta. I was ready to try to reconstitute a path back to my childhood.

Bill was away for three months on a Senior Smithsonian Fellowship back in Washington, DC. Alone in the house and untethered from the world I knew in Washington, from friends and colleagues, I was ready to open doors and try to capture my elusive early self. I went to the guest room and carried the boxes one by one down the stairs and began to spread their contents onto the dining room table, a block of beautifully grained cherry that somehow seemed a receptive surface, perhaps an unconscious association with how important the dining room was when I was a child: where my grandfather had sorted photographs, where I would sit and watch my father work, where holiday meals were celebrated.

Family photographs again before me, I studied my father's face more carefully: not a particularly handsome man, but his smile and sparkling eyes and confident stance made him appealing and engaging. Though only five foot four, with a big barreled chest, his demeanor exuded a certain confidence. So many photographs show him with this wide engaging smile, happy and expansive. There were photographs of my mother and father, newly married, in a series of meditative and romantic poses cast in deep shadow, probably taken in our living room. I tried to imagine the circumstances that inspired these photos. I looked more carefully at the ones from their honeymoon, my mother tenderly clinging to my beaming father. There were also images of them as young parents looking at my brother, Robert Allen, born in 1936, with joy and wonder. I saw my mother anew as a gentle young woman, demure, sometimes shy, almost never ebullient. I sensed she grew up in a family where she was adored, especially by her brothers, but she may have been overshadowed by the strong and extroverted personality of her mother. She was certainly reserved, and her photographs seem to suggest that she rarely let herself go in an impetuous way. But she seemed happy with my father.

I gathered images of myself as a baby and a young child, round face with curly hair, looking gentle and sweet with a big tummy. I laughed at one of myself, age three or four, smiling at the camera

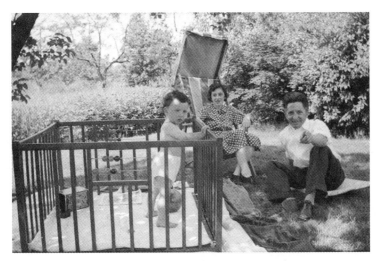

Mother and Dad with Bobby, our backyard, 1937

while my underwear hung half below my skirt. There are others with my brother and my parents at birthday parties in our dining room where I almost always have an open if slightly shy smile. I lingered over images of me at age nine or ten in my favorite dance school costumes, looking extremely proud and vivacious, even a little alluring! Others show me holding kittens with my brother and our cats Tiger and Dickie, who for us as children were almost like siblings.

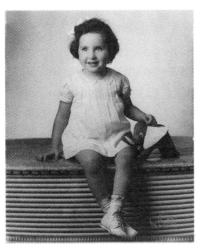

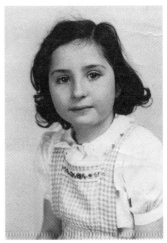

Age 2 *Age 5*

Some weeks later I finally turned to the hundred or more letters to my parents and theirs to me, trying first to sort them chronologically. Tentatively, I began to read them. They were a visceral record of memories and feelings beginning when I was twelve. I plummeted back into emotions from so many decades ago. Sometimes I could almost be my twelve- or fourteen-year-old self again before the present returned. I began to remember things I hadn't been able to recall in over fifty years. It is hard to explain just how out of focus was this early period of my life, almost lost from memory. My feelings for my father, who died when I was twenty-seven, were stuck back in time, stunted by the painful emotions and trauma of my teenage years and our difficult encounters, and the self-protective amnesia that followed.

Now with these photographs and the letters, I began slowly to calibrate and recalibrate in ever smaller pieces the memories of my life, and to think more deeply about my childhood years, and especially my father. But it was not easy to read these letters, and sometimes extremely painful; there was a rawness to this exploration I didn't expect or anticipate at my age, and it affected me deeply. They began to unlock emotions walled up for a very long time, which even years of therapy had never fully uncovered. I remembered my first therapist, Dr. Schattner, who helped me enormously in my twenties, trying to explain a dream. In the dream I was driving on Route 59 in my hometown, and a man on the side of the road kept urging me onward. Dr. Schattner thought he was the man, trying to help me walk further back into the past. I never could go back until now, when for the first time in my adult life I had come to a full stop. I was living in slow time.

I began to think about my parents, long since dead, with enormous compassion and tenderness, and to contemplate their lives separate from my brother and myself. My parents had a good marriage. In their love letters, they always addressed one another as "Sweetheart." They missed each other terribly when apart, and even ten years after their marriage, when my father was working

in Florida, they sounded like lovesick teenagers. My father wrote my mother, "Today is six weeks since I held you in my arms and kissed you goodbye. How much I would give to have and to hold you again, for I do love you, dear, and miss you very much. My mother during this same period: "Do you know, darling, you really are my sweetheart. I'm sure in love with you, dear. I can't get you out of my thoughts, you interfere with my work, you are just everywhere. . . ." She signs the letter, "Your lovesick wife." I was not surprised to read this; I always thought of them as happy together despite their age difference. They rarely fought. While my mother, by her own admission, was outwardly contained, I think she shared a deep intimacy and openness with my father. Although more reserved than him and not overly demonstrative, she was certainly loving and giving.

The first ten years of my parents' marriage were framed by the Depression and World War II and the presidency of Franklin Delano Roosevelt, whom they greatly admired. They both worked hard and depended on two incomes to help support their parents through the Depression and the decades following. In 1942 Dad was the engineer in charge of Camp Shanks, a port of embarkation for soldiers during World War II. He continued to work for the State of New York, supervising road construction in various communities north of Nanuet, including Poughkeepsie, and was one of the lead engineers for a portion of the Palisades Interstate Parkway to Bear Mountain. My father had a second job running his own survey business in the evenings and on weekends. He would occasionally accept an in-kind payment, including on one occasion several paintings by the Hudson River artist Albert Insley, whose family's farm was next door. I grew up with these paintings and a few now hang in our house, among them one of the Insley family farmstead.

After she graduated, my mother had worked as a lab technician at Sydenham Hospital at 125th Street and Lenox Avenue in Manhattan, and once married, she opened her own business, Rockland Analytical Laboratory, licensed by the State of New York. She was extraordinarily ahead of her time. A small room added to the

back of our house was her laboratory, replete with sterilizing equipment, a microscope (which I still have), slides, and an array of test tubes, small bottles, chemicals and staining liquids, and medical tools, including dissecting equipment. I was always very proud of the large yellow sign for her business, positioned at the end of our driveway on the main road into town, and still have copies of her lab's stationary. People came to the house to drop off urine samples and to have their blood drawn while they sat on our living room couch. As a little girl, I would sometimes watch from the dining room as my mother pricked a patient's finger. She also did water analysis, collecting her own samples to ensure they met her sterile standards, and as a result Mother never drank tap water, only seltzer. She also did, to my horror as a child, pregnancy tests on rabbits out in our garage.

Mother was a role model for all her nieces and obviously for me, her daughter. But she also balanced many other roles, caring for her parents and her in-laws, including taking the bus each morning to Spring Valley for a year to give Grandfather Nathan morphine shots as he lay dying of liver cancer. She later served as the family matriarch in terms of the Jewish holidays. She had little help except for Ethel, who came in a couple of times a week. I have memories of the scrub board where my mother and Ethel washed clothes and later hung them on the clothesline.

The two-story, gray wood-frame house my father bought in 1930 and where I grew up was probably built as a two-family house. My father added two small rooms to the back of the house and a porch on the second floor over one of the rooms. My grandparents lived from time to time on the second floor, and for a few years it was rented to a young family, while we lived downstairs. When I returned to Nanuet for my mother's funeral in December of 2002, my husband, Bill, and I stopped at the house, which its new owners had turned into a medical office. I had tried to visit with Bill once before, but they wouldn't let us in. This time the nurse at the door again hesitated, and I pleaded: "I am burying my mother today, please let me come inside; I need to see where I grew up." Things

had changed, of course, but the structure of the house was there. It was a simple home with only one bathroom for the downstairs, off the kitchen. I felt like tiptoeing, not so much because it was a place that no longer belonged to me, but because I was sharing memories with my husband for the very first time. It was a moving but also disconcerting experience to be doing this just before I buried my mother next to my father and brother and grandparents—my entire family.

The kitchen and pantry, the gathering place for the family when I grew up, was no longer recognizable, but I could still instantly recall the enticing aroma of pies and cakes and meal preparation that filled our home. The living room and the dining room with their big windows were clearly intact, as was the layout of the three rooms and simple kitchen on the second floor. I could see in my mind's eye the baby grand piano in the living room and how I suffered music lessons with a tone-deaf ear. The large brick fireplace so central to our winter evenings still dominated the room, as did memories of our cats sleeping by the fire.

My bedroom as a little girl, at the back of the house facing out to the woods, was now a supply room. Still very much the same was the cellar where our cat, Tiger, had sometimes as many as three litters of kittens a year. As kids, my brother and I spent hours trying to find where Tiger hid her kittens, and the cellar was also where my brother started a hamster business while my parents were away, with dozens of hamster wheels running all night! The cellar with its hanging bare lightbulbs and damp smell was always a mysterious place, especially the small locked room where my mother kept canned vegetables and fruits and where, later, my father kept presents like special liquors and perfumes he would buy when they traveled. I would often sit on top of the slanted cellar door to eat tuna fish sandwiches and look out at the heavily wooded area behind our house, probably remnants of the nineteenth-century Insley or Blauvelt farms, now obliterated by a housing development.

I recently read our Irish friend Tom Dunne's brilliant book, *Rebellions: Memoir, Memory and 1798*, which explores the concept

of identity and a profound sense of place. Part memoir, part history and infused with detail, it evokes the area around New Ross where he grew up in County Wexford in Southeast Ireland. It was here that his forebears farmed and fought over two hundred years ago in the Rebellion of 1798, initially a rebellion against British rule that ended in the massacre of unarmed Protestants, including many women and children. His brother still lives there. Tom's emotional and intellectual engagement with this area intrigued me, especially as I began to write this memoir. In contrast, I felt little emotional connection to Nanuet and had locked away so much of my childhood that I couldn't even recall the names of the stores on Main Street that were walking distance from my house. I had to research the town as it existed in the 1940s and 1950s to remember.

Nanuet was named Nannawitt, after an Indian chief who was a member of the Kakiat tribe and negotiated a settlement with the first European settlers in the area, the Dutch. The Revolutionary War Battle of Stony Point in 1779 took place just miles from our house. In 1841, the Erie Railroad made Nanuet a station stop, but the town remained rural, a small village comprised mainly of large farms. Even in the 1940s and 1950s, Nanuet was a quiet, strangely rural place despite the fact it was only twenty-five miles from New York City and part of a string of small towns and hamlets including Spring Valley, Nyack, Pearl River, Stony Point, New City and Monsey, just a few miles apart from one another. It wasn't until the Tappan Zee Bridge, opened in 1955 to cross the Hudson River and link Westchester County with Rockland County, that the area began to become more suburbanized.

Mainly a blue-collar and working-class town, Nanuet could have been small town USA anywhere: Main Street had maybe twenty buildings, including Keyrouse's Drug Store, Perino's Market, Nanuet National Bank, and several bars, among them the Red Rail Bar, which was rumored to be a whorehouse. The annual Memorial Day parade would go by our house on South Middletown Road as it entered the center of town. Lederle Laboratories, located in the next

town, Pearl River, and a mile away from our house, was an important distinction for the area because it invented aureomycin. But other than the smell of chemicals that would frequently permeate the air, I am not sure its presence otherwise impacted our lives.

Nanuet had a highly rated elementary school, where I received an excellent education. The school was a positive anchor of my childhood, and it was here that I experienced an intellectual awakening, discovering the world of knowledge that I could uncover through reading and research. By the time I was in seventh grade, I was engrossed in preparing long science reports, complete with precocious detail including charts and drawings. I collected rocks and fossils and spent hours reading about them in the *Encyclopedia Britannica*, my form of Google growing up. My father would bring me back all kinds of amazing rocks and fossils from his road projects.

The school is also linked to my memory of Nanuet as a physical place: my immediate world was defined by neighboring streets and by the woods behind our house with its paths that could take me to an old cemetery and to my school. Behind the school was a stream fed by a larger pond. I would walk there by myself and have a picnic lunch, listening to rivulets moving over small pebbles and stones. In the winter, everyone would ice-skate on the pond, and when I would come home from skating my mother would always make hot cocoa with marshmallows and cinnamon toast. As a young child the woods sometimes scared me as I worried about being eaten by wolves, having listened to too many Little Red Riding Hood records. But as I grew older it became a playground for my imagination as I hunted for Indian artifacts and precious stones and fossils among the glacier-strewn boulders and rocks that defined the topography, hence the name of the area, Rockland County.

What I remember vividly about my childhood is the natural world, the change of seasons. I was attuned to the outdoors and the changing smells and colors of my front yard and the woods behind. I can still feel viscerally the hot, steamy summers with the attic fan trying to cool the house. The area enjoyed amazingly beautiful falls

with brilliant red and orange and yellow leaves, so vividly captured by Hudson River artists like Jasper Francis Cropsey. I would jump with abandon into the huge mounds of musty leaves my brother and I would rake. We had a blazing red maple in the front yard and a funny old apple tree alongside the driveway that bore wormy fruit every year and from which my cat, Rusty, once fell and was never quite the same. Winters were special: there were stacks of wood by the living room fireplace, which was always burning, and where our cats often slept in baskets nearby, absorbing the warmth. Embers burning in my fireplace today still evoke memories of my childhood. Snowmen and snowball fights were ubiquitous. Winter was also a little dangerous, especially when I would careen down Blauvelt Street or the neighboring cemetery with a sled I could barely steer—I was usually the only girl in the group.

I can still smell the arrival of spring and the intoxicating fragrance of honeysuckle and Lily of the Valley that seemed to be everywhere; today I grow peonies because they were so much a part of my memory, lining the side of our house in late spring, although mine are never as fragrant as those of my youth. My father had a victory garden that he continued for years after World War II. I loved the smell of the garden, of manure and tomato vines, and I still dream about the layout of this land, although I don't remember helping him in the garden. Gardening is one of the great passions of my adult life.

As I thought more deeply about the construct of a profound sense of place, I realized that while I did not feel this for Nanuet, I did feel it for the Hudson River, a spectacularly beautiful river with its majestic palisades and great breadth. My parents frequently took us on drives along this river, sometimes traveling north to West Point. I have vivid memories of decommissioned World War II destroyers lined up along the banks of the Hudson and brilliantly colored leaves reflected in the water in the fall. In the winter we sometimes went to Bear Mountain to sleigh-ride down steep hills. As a young child, I for some reason found the Bear Mountain Bridge

suspended over the Hudson River so heart-stoppingly frightening, an early harbinger of my fear of heights.

The emotional pull of the Hudson River is still strong for me, something I didn't fully appreciate until my husband, son, and I spent three years in San Antonio, from 1981 to 1984. I was profoundly disoriented by our stay in Texas, in part because of the dramatically different physical environment and the lack of four distinct seasons. When we moved back east to Washington, DC, one of the first things we did, before I started work, was to take a trip along the Hudson River, driving to upstate New York, stopping at an inn along the way to celebrate our fourteenth anniversary before continuing north and eventually finding the source of the Hudson. I'd needed to come back to the place that was my source, the beautiful landscape framing the Hudson River and my memories of spectacular autumns with brilliantly colored leaves reflected in the water, and share this with my husband and son. I felt immensely restored.

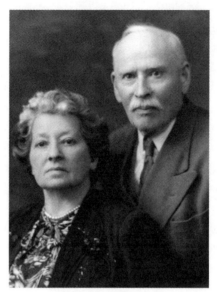

Grandma Betty and
Grandpa Freedman, 1940s

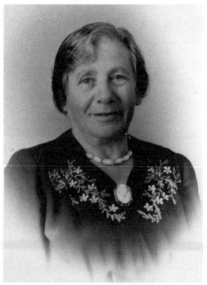

Grandma Rose, 1940s

3. Enticing Aromas and Family Dynamics

My efforts to enter the more interior world of my childhood were at first tentative. Memories and images of family dynamics came back slowly but not in any coherent sequence; I gathered them together patiently. My childhood was framed by the comforting presence of my grandparents, my mother's father, Louis, whom I called Grandpa, and Grandma Rose, with one or the other living with us on the second floor of our house for many years. They somehow stood like protective sentinels as I began to recall my early self. My parents' love for them and respect for their orthodox beliefs deeply influenced my early years. I didn't know my Grandfather Nathan Dorfman, who I am named after, as he died in 1940 before I was born. I have very few memories of my mother's mother, Bessie, before she suffered a massive and debilitating stroke in 1947 that left her unable to speak. My most poignant is of her son, my uncle Emil, who would so lovingly kneel by her chair, trying to understand what she was saying. Bessie was apparently a dynamic and vivacious

personality, full of fun and energy, who after selling the Dew Drop Inn opened a Viennese bakery and restaurant in nearby Spring Valley where, after lunch was served, she enjoyed playing cards with her friends, serving tea in fine china cups.

I adored my grandpa, a distinguished and handsome man with a quiet and refined demeanor, who lived until he was ninety-five. He seemed extraordinarily wise to me and commanded enormous respect at the holiday dinner tables that he led with solemn orthodoxy and a twinkle in his eye. He enjoyed his last years, knowing he had lived an interesting life and was deeply loved. When he lived with us, I often fixed him breakfast, and he liked to spend much of the day in "his chair" in our living room next to the piano, reading the *New York Times*. I was also close to Grandma Rose, but she was very different. She seemed more wounded and somber and could be neurotic and difficult. She was also fanatically orthodox. As a child, I was fascinated by her small kitchen and the exotic smells, so different from my mother's, that came from the tiny pots simmering on her upstairs stove. I would watch her cook from the hallway, almost like a cat hoping to be given a taste. But she liked me watching her. Her daughter, my aunt Esse, and Esse's husband, my uncle David, made annual visits from Denver to see her, which I always looked forward to. I remember how naughty my uncle could be with me, once drawing caricatures on the wallpaper near my bed, which I cherished.

My parents kept a kosher home for my grandparents with separate sets of dishes and silverware for dairy and meat food. After my Grandma Bessie's stroke, my mother became the matriarch of her family and all holiday meals were held at our house, with her brothers Leon and Emil and their families, which included my three cousins, Patty, Claire, and Allen, and occasionally other relatives in attendance. As I closed the door on Nanuet, I did so to a degree with my cousins as well, nothing to do with them personally, but I had put that world so far away. We should have been closer. My loss.

There was always something special about the ritual of Passover—the cleaning of the kitchen and setting out the pink glass Passover dishes—which also marked the coming of spring and passage of another year. I looked forward to my mother's matzo pancakes smothered in sugar. Grandpa led unbelievably long Seders, sitting at the head of our dining room table, a ritual that mesmerized me as a child as I tried to comprehend why it was so important and why the Elijah goblet, which sat on the table year after year, was still filled with wine at the end of dinner.

Mother was an exceptional cook and prepared all the traditional Jewish foods that were part of Sabbath and holiday celebrations. She would cook for days before major holidays, grinding her own chopped liver and gefilte fish, curing her own lox and herring, and making traditional flourless cakes and rugelach. I appreciated the meaning of the holiday table, especially the solemnness of Rosh Hashanah and Yom Kippur, the Day of Atonement, and the identity connection it represented. One of my mother's most treasured possessions was her mother's very fine Limoges china fish platter and set of eight plates decorated with fish patterns and hand-painted gold rims circa 1900, which were used for the holidays by her family for over sixty years. This set meant so much to her that she begged her two sisters-in-law to give her the few plates they had so she could have the complete set. It is now among my own cherished heirlooms.

Watching my mother's loving preparations, I came to recognize early on how in Judaism women passed on religion and culture through the holiday meals and family gatherings in the home. This was very different from what my Catholic friends experienced: they went to church every Sunday, while I would go to temple only a few times a year for the high holidays and later for Sunday school. Nanuet had a sizable Italian Catholic demographic served by St. Anthony's Catholic Church. From early on Catholicism intrigued me because it was so different than anything I knew growing up in a Jewish home, especially the concept of confession and the fact that

some of our neighbors could drink and womanize and then go to confession and everything, apparently, would be fine.

Our tiny kitchen was a happy place, the center of activity and the heart of the house and always filled with enticing aromas. It was also our playroom, where we did messy things like finger painting or making plaster of paris molds on the small kitchen table. An awkward space with the bathroom off one end and the pantry and cellar door off the other, it did not deter my mother from cooking delicious meals. For my mother, cooking was an act of love and deep pleasure; it was also how she honored her parents and mother-in-law, filling the house with fragrant smells of East European mainstays like her Russian borscht, slightly sweet stuffed cabbage, and first cut brisket rich with onions and gravy. She was also an exceptional baker, and, like most children, I looked forward to tasting cake batter and waited impatiently for her delicious apple and peach pies, made with a flaky pie crust and rich with cinnamon and brown sugar, to come out of the oven. She used this same flaky crust for her chicken potpie filled with leftover chicken, carrots and peas, and a deliciously fragrant chicken sauce that bound it all together. Occasionally Mother "ordered out" from a German lady, Mrs. Herman, who made delicate lemon meringue pies and sugar cookies. These amazing cookies, rolled incredibly thin so they melted in your mouth, were cut into diamonds and clubs and hearts and spades and stacked neatly in white boxes tied with a string. Birthdays were major celebrations when the house would be decorated with streamers and balloons, and my mother would make her famous magic birthday cake, a large twelve-inch cake baked in three different layers, pink, yellow, and blue, which she would ice with chocolate pudding and then cover in whipped cream.

As I grew older, I began to share the kitchen with my mother, watching her cook and especially bake cakes. She taught me the scientific basis behind baking, impressing upon me the importance of precise measuring and exact temperature, and I still experience the

sensual pleasure of beating together butter and sugar until they are perfectly fluffy and then blending in eggs one at a time and slowly adding the sifted flour alternating with the liquid until just blended. By age thirteen, I was collecting my own recipes. Eventually, I occasionally made cakes for my parents' dinner parties, the most spectacular being a rum cake with a chocolate filling that became my father's favorite. In time I became an accomplished cook in my own right, and my mother would borrow some of my more modern recipes. I still have her handwritten recipes, many stained from use and age, with hopes one day I might put together the recipe book she wanted.

When I tried to conjure up my childhood in terms of my brother, Bobby, and family dynamics among the four of us, my memory became more clouded, specific episodes difficult to retrieve. My brother is elusive, a beloved, mysterious presence I can't quite reach. He was five years older than me and as a result we didn't play a lot as children, although we did have a deep bond, and he seemed to enjoy his big-brother role. I can see from early photographs he was a sensitive and probably shy child with a very sweet smile. By the time I was five, I was aware Bobby was different in some way. I asked my mother at some point what was wrong with him, and she told me he had eaten a worm as a toddler while sitting on the grass. I never asked again and never really knew; what troubled him was like a secret. Recently, in reading some of my mother's letters to my father, I learned that at age three or four they took him to a psychiatrist in New York City to be evaluated and a few years later, in 1943 or 1944, my mother took him back for a follow-up assessment. After the visit, she wrote my father, who was working in Florida, that his speech had improved but she was still concerned about his "tenseness" and "tightness and feelings of insecurity."

It is so painful to acknowledge how little I can recall about my brother growing up; I try to reach back, but my most vivid

memories are of my father and him arguing at the dinner table.
He was somehow a mysterious presence in my childhood and even
my young adult years, a brother I loved but, perhaps because he
was five years older, didn't know well. I can recall gestures and
movements and an awkwardness, especially in his smile, and a
vulnerability. I can recall his playful touch on my shoulder, but
as I reach back, I can't remember a real intimacy, although I know
he loved me and was very generous to me as a teenager and later
in life. I certainly loved my brother and missed him when he was
away at college at Duke University and North Carolina State Uni-
versity. I think of Bobby as an immensely good and kind person,
intensely honest, with a capacity for friendships, keeping in close
contact with childhood and college friends throughout his life.
But he could be socially awkward and didn't always participate
well in a group conversation and the back and forth of normal
exchange, especially when he didn't feel comfortable. He had ner-
vous twitches and could be tense and emotionally overwrought
and hard to approach, and there were occasional angry flare-ups
and at times he could be very emotional. I know I worried about
him and when I think of him, I remember his warmth, but also
tension and angst, maybe even something a little tragic. I struggle
to recall more but can't reach it. As I write this my heart aches—
what am I not remembering? Why is it so painful?

My brother and I were so different that it was sometimes
difficult growing up to find common ground. He certainly wasn't
interested in clothes, and as an adult his office was unbelievably
chaotic. He didn't share our parents' or my intellectual and cultural
interests, and he was much more politically conservative. Whether
this was intentional or something he truly couldn't relate to, I don't
know. Bobby liked to say proudly that he was a country boy and
preferred to "be a big fish in a little pond rather than a little fish in
a big pond." I always wanted the big pond.

I would never have called our house easygoing. I definitely felt
loved and well cared for, but I don't remember much silliness or

laughter. Dad suffered from insomnia, often pacing the house at night and raiding the refrigerator. My parents worked extremely hard—my father had two jobs and was frequently stressed—and there were times money was scarce as they also cared for their parents. My mother worked almost daily in her laboratory, and her income was often critical. Both my parents could be exacting, and my mother was given to nitpicking, which is where I probably got my drive for perfection. My cousin Allen Freedman recently told me, "I had a sense in your family nothing was good enough." My mother could be strict and overprotective; I have vivid memories of fighting with her in first grade about having to wear a snowsuit to school on what I thought was a warm day. We arrived late for school that day, and to my acute embarrassment our class picture shows me standing next to my teacher in a snowsuit while the rest of my class posed outside in shirtsleeves!

Our most relaxed time as a family was when we would go in the summer to Atlantic City, vacations I remember with happiness. I would look forward to the boardwalk and ocean and staying at hotels, where my great indulgence as a kid was cornflakes and heavy cream with lots of sugar. I relished the time at the beach because my brother played with me, and we would spend hours doing arcade games together on the boardwalk. We both developed a lifelong love of beach vacations.

Mother and I went several times a year to New York City, easily accessible by bus; I have clear memories of sitting by the window as the bus would wind its way through endless small New Jersey towns. I was terrified as a young child of seeing, in the streets of New York, World War II veterans on roller-like boards because they had lost their legs. We would shop for clothes and eat at an automat, and at Christmastime walk along Fifth Avenue peering at amazing holiday window displays. But the highlight was always going to the Museum of Natural History. I was intrigued by the displays of rocks and the planetarium and especially the exhibits on human anatomy. Over the years Mother encouraged my interest in

science, patiently showing me her equipment—test tubes, beakers, stains, chemicals—and all the medical tests she would run. I was fascinated by her microscope, and my lifelong sense of curiosity was definitely stimulated by her work. In terms of culture, my parents tried unsuccessfully to have me learn to play the piano, but I found my dancing classes magical, especially toe dancing, and wearing the beautiful costumes I had for *Swan Lake* and the *Can-Can* that made me feel special.

Dinnertime was sacrosanct in our home. My parents felt this time together as a family was very important: the telephone was never answered, and the television and radio weren't allowed on. Both were deeply engaged with politics, especially my father, and there were heated political discussions between my brother and father around elections. We created presidential electoral charts and would watch election night results, trying to predict who would win. Our dinner conversations were stimulating and had an enormous impact on me, especially during the McCarthy era when Dad would talk about what was happening in the congressional hearings; his views were so liberal that my mother feared he might be considered a leftist sympathizer. Dad would explain McCarthy's attempts at character assassination and his unethical tactics and the entertainment blacklist. These substantive dinner conversations deeply affected me. I absorbed a sense of what deep integrity meant and the nuances of moral right and wrong, and that it was important to have the courage to stand up for what one believed, even at some personal costs. It was a core value imbued in me forever, and this would play itself out later in my professional life. After dinner, Dad would often spread his survey work over the dining room table and take out his drawing instruments, which he kept in a rectangular leather case I still have. I often sat quietly at the table, watching him draw survey plats, sometimes the only alone time I had with him during the week.

I cherish my time alone with my father. One of the most meaningful memories I have as a child, probably before I was even ten,

was taking walks with him at night, sometimes just in the driveway, and looking up into the heavens, which in those days were crystal clear, with the Milky Way regularly visible. He led me to grasp the awe and mystery of the universe and how it changed his thinking about religion. Despite my father's orthodox upbringing, he told me he didn't believe in a personal god and whether there was a god or not wasn't important to him. What mattered was the here and now and how we lived our life on earth. He explained to me that his religion was being honest, generous, and helping people who needed things more than we did. It was one of the most important things I brought forward from my childhood.

These conversations encouraged independent thinking and confirmed my reservations about the rituals of religion and my agnostic beliefs. Although I experienced anti-Semitism, like taunts from schoolmates and chalk-drawn graffiti on streets near our house, I harbored my own kind of prejudice and didn't embrace my Jewishness, nor did my brother. I also made the judgment, probably unfairly in retrospect, that there was a difference between the more intellectual Jewish identity that I associated with my father's family and what I perceived as the more vulgar and stereotypical New York Jewish mannerisms I perceived in my mother's aunts. As a young child I found them loud and bossy and even scary. My father kept his distance as well, and I suspect he never felt fully welcomed in my mother's family except by Grandpa, who was the only one who initially approved of their marriage. My Nanuet cousins, on the other hand, found my father somewhat intimidating and different from the Freedman family, perhaps because he was older. Despite my Jewish upbringing and my closeness and respect for my grandparents, it was hard for me as a teenager to embrace my Jewish identity. I never felt comfortable in the synagogue, and I wasn't into ritual. My brother and I were adamant we open presents on Christmas like the rest of our schoolmates. A friend recently mentioned she was always surprised there was nothing Jewish about me, not even a Jewish sense of humor or use of Yiddish expressions. I cultivated that.

Family dynamics were complicated: I was acutely aware of the tension between my father and brother and their frequent clashes over small things like Bobby's table manners and their sometimes explosive blowups, which seriously scared me. I know that my brother felt he was a great disappointment to our father, which pained him deeply and made me sad, a sadness I can still feel. Bobby found refuge at my mother's brother's house, our uncle Leon, with whom he was close, and he frequently played with our cousin Claire, Leon's daughter, who wore corrective casts as a child. Claire adored my brother, and they often played board games together, many of which he invented. Apparently, he was happy and relaxed with my uncle, who was a great tease, as was my brother. Although they lived nearby, I don't remember spending much time there, but then I was younger than Patty and Claire.

My mother was deeply protective of my brother and always tried to intervene and compensate for him, her hovering presence, shielding him from criticism, an image long forgotten but now so clear in my mind. He was certainly more the focus of her attention than me, and although I never doubted as a child my mother loved me, I suspect I was aware that my brother's needs came first. It is only now that I can look back and see that I had to compete for her attention. I would always try to do my very best, but somehow I also knew not to outshine my brother. I must have understood on some level that the subtle and not so subtle dynamic of their interaction could devalue me. A sensitive and intuitive child, it had to be a hard dynamic for me growing up; my cautious dance for attention undermining a sense of my own strengths. At some point I learned—I have no memory how—that my brother had a higher IQ than I did. And, however it was communicated, it had a huge impact. I also concluded, probably rightly, that I was my father's favorite and that he enjoyed having a girl. Although he worked hard and could be preoccupied, Dad took time to do things with me and made me feel special.

I always felt—and still do—the need to do my very best. I

wanted things perfect, whether baking a cake or writing a school report, and I craved constant reassurance, to have it reinforced that whatever I had done was not only good but excellent. But it wasn't until now, as I reread letters my brother wrote me from college, that I finally had a perspective on some of these family dynamics. I had been admitted at the University of Colorado at Boulder and put on the waiting list at Goucher College in Towson, Maryland, where I desperately wanted to go. When Goucher finally accepted me, I was spending the summer in Denver. My brother immediately wrote me, in his nearly illegible handwriting, and urged me not to go. He told me nine out of ten girls would be smarter than I because I had been on the waiting list. Regardless of how hard I worked, he was certain I would still be in the lower tenth of my class and miserable. Although he thought because of my perseverance I could graduate, he was adamant in his recommendation that I shouldn't go. My father, on the other hand, was thrilled I was accepted and so glad I had gotten my wish to have a good education. He felt my "whole life would be different" because I would be going to Goucher and wrote he expected so much of me because of my "high level of intelligence and fine mind." I don't have or remember my mother's response.

I have absolutely no memory of these letters or their impact, but rereading them some sixty years later, I understood that while my brother in these letters may have thought he was being protective, wanting me to take an easier path, there was almost certainly a more complicated dynamic going on, one that undermined my strengths and suggested that I was somehow not capable. In retrospect I can see this dynamic continued to play itself out even as adults decades later. With my mother's blessing, I organized a seventy-fifth birthday party for her at her apartment in Fort Lee, New Jersey, for family and friends, creating a beautiful menu. As the date got closer, my mother and brother decided I wouldn't be able to do this. They insisted it would be too much for me, and we should have it catered. Their protestations went on for days.

I was at first incredulous and then quietly furious. The implicit message was I was not capable of doing this. I was forty-five, and I was and am a great cook and party giver. I finally took charge, as I can do, and said I am doing this. I wanted to cook for the extended family, something I had never done before, and I didn't want to hear any more.

Did my brother and perhaps even my mother not want me to shine? I have no idea. It was a memorable party with delicious food. From my mother's apartment on the Palisades, high above the Hudson River, we saw the Manhattan skyline before us and even the Little Red Lighthouse from her childhood, still standing by the George Washington Bridge.

My mother's and brother's reservations deeply upset me at the time, but it is only now that I understand how entwined they were in some long-established dynamic that somehow devalued me. In my brother's narrative I may have also needed to be submissive. Maybe this is why, even as an adult, I still wanted my mother's compliments, to be told I had done something well. When I was in my fifties, a member of my staff heard me on the phone with my mother and listened in disbelief as I almost begged to be complimented. She finally understood why someone as capable as she thought I was needed so often to be reassured.

I essentially experienced a relatively normal early childhood in a small-town environment. I was a bit lonely since none of my friends were in walking distance, and therefore I spent a lot of time in my own inner world, which may account in part for my introspective nature and need for quiet time. On some level, growing up in Nanuet may have been idyllic. I could wander safely in the woods behind my house, hoping to discover Indian ruins or precious stones deposited by glaciers. Milk was delivered to the door; we would drive a few miles to Conklin's Farm where we would get freshly picked corn and apples. We canned string beans and

tomatoes from the garden and made wild blackberry jam. But I felt there was something limiting and stultifying about its smallness, a perception I may have absorbed from my parents. Nanuet's provinciality became especially clear to me after my first trip away to Denver, when my whole world changed.

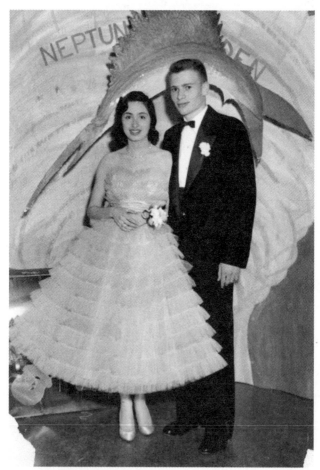

At Grant's Senior Prom, 1956

4. My First Love and
a Traumatic Rupture

My aunt Esse and uncle David were extremely important in my development. I flew alone to Denver and spent part of the summer with them when I was fourteen and a half, before beginning my sophomore year in high school. This trip was in many ways a seminal experience. I saw the Rocky Mountains for the first time and was exposed to a different way of life, more social and intellectual than anything I had known, and something my parents wanted me to experience. My aunt and uncle had a rustic summer cabin in the mountains, a sophisticated place filled with books and an important collection of Native American basketry and jewelry, with some pieces dating from as early as 1880. Esse enjoyed entertaining on their large screened porch, frequently grilling on an outdoor fireplace. Barely five feet tall, she would greet friends wearing these amazingly beautiful nineteenth-century squash blossom necklaces made of heavy silver with huge pieces of turquoise that practically overwhelmed her small frame. I was drawn to her exotic jewelry and treasure the pieces she gave me.

Over the years, I made several trips to Denver, and my aunt and uncle helped mold my intellectual aspirations and sense of

sophistication. I also became close to their daughter, Maxine, and later her husband, Fred, forming a bond with them I never had with my Nanuet cousins. I came to love deeply the incredible beauty of the Rocky Mountains and the isolation of the cabin, where occasionally wild horses would roam. Colorado was also a haven for my father, who had traveled by train across the country to visit his sister in the darkest hours after his divorce, and years later when the strain of work left him exhausted and depressed.

Before I left on this first trip, I developed a crush on my brother's friend Grant, who was two years older than I. When I returned home from Colorado that summer, I began daily walks to the Dairy Queen where he worked, just up the street from where we lived. The interest was soon returned, and we eventually began to date, going to the movies and neighborhood hangouts, having ice cream together, and taking rides in his white MG. Nothing could be more exciting for a sophomore in high school than riding around with a good-looking guy in a convertible. My brother, who by that time was at college, was initially jealous, telling Grant he had to choose between him as a friend or me. They resolved that. I am not sure how, but I was no longer my brother's pesky little sister.

Grant was my first real boyfriend and my first love. We dated for two and a half years. From the beginning there was a strong physical attraction and an emotional connection, and we could talk for hours together. He was handsome and thin with high cheekbones and light brown hair, and he looked a little like the movie star James Dean. Grant had two older sisters, and his father had died when he young, possibly in World War II. When we got close, he proudly showed me his father's combat medals. His mother remarried and Grant seemed to get along well enough with his stepfather, a physician, but he was a bit of a lost soul, no more so than any of my brother's other friends. I think our home, at least initially, was a bit of a refuge for him, and he was also addicted to my baking. He found me fun and beautiful and kind and someone he could confide in; when he left for college, he told me I was perfect, and he wanted to do his very best for me.

It is hard for me, after so many years, to remember the details of the drama that ensued over my first teenage love. That might have been possible at one time, but I threw out almost all our letters when I moved to Atlanta in 2012, something I obviously regret now as I struggle to recreate what happened. I had kept them for over fifty years, tied, I am embarrassed to say, in pink ribbons. The few letters I have left, written to me during my senior year, acknowledge the depth of our love and connection. Without two years of my half-written diaries, discovered in those attic boxes, I could never have penetrated through the amnesia this episode precipitated.

Having a boyfriend was a new experience, and I was obviously feeling all sorts of new and sometimes confusing emotions. After dating for six months, our feelings began to deepen, with Grant declaring his love first. I was more hesitant. Once it became clear to my parents that there was a strong physical attraction between their daughter and a teenage boy, my father became another person. He seemed to me crazed, obsessed, and pathologically suspicious. While he continued to let us date, every time Grant and I went out he would lecture us on how to behave. When we drove up to the house after a date, my father would be at the window to make sure we didn't kiss goodbye, and he would then go outside to inspect the tires to see if there was dirt on them, indicating we had parked somewhere. At one point that first year he became so vehemently opposed that he forbade me to see Grant, although we continued to talk on the phone. With my brother's intervention, my father eventually relented and even let me go to Grant's senior prom at Nyack High School. I have a picture from that prom and found a few other images of us together, slides I had carefully kept. I look at myself, a stranger, dressed in a plaid shirt and bobby socks, my arm in his, alive with a broad contented smile; another showed us, two teenagers dressed for the prom, me in a ruffled lavender gown looking beautiful, he in a tuxedo, such youth and innocence. I hadn't made this up.

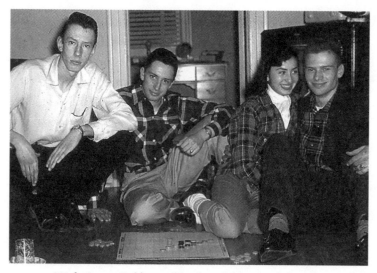

With Grant, Bobby, and his friend David at left, 1957

Grant and I corresponded almost daily during his first semester at Michigan State University—hence the stack of letters. I missed him terribly and he me, and our connection remained strong. I can still remember the moment I first saw him after he came home for Christmas that first year. I was slowly coming down the stairs in a stylish sheath dress, and he looked up at me, saying, "Hi, beautiful." I realized for the first time what it meant to be beautiful to a man. Despite my father's watchful eye and admonitions, we saw each other constantly over Christmas vacation, happy together. I was beginning to feel like I was really falling in love. It was for me an overwhelming sexual awakening lying entwined in his arms, although in those days and norms our physical contact was limited to "heavy petting." Our time together was intense and wonderful, as only young love can be. We double-dated with friends and even his sister, went to the movies, and just hung out at Nanuet's ice cream and sandwich shop. His Christmas card that year was a declaration of love.

After Grant returned to college, my parents began their assault, restricting our communications to one letter a week and occasional phone calls. We sometimes put seven letters in one

envelope, which my father soon discovered. I was desperate with longing, waiting for Grant's letters. On one occasion my father withheld them for several days; I sobbed in anger, returning to my bedroom after he gave them to me. Dad became increasingly controlling and angry, and there were threats I could never see or speak to Grant again. I was simply uncomprehending of my parents' behavior. They accused me of making love, which I denied—it was amazingly innocent—and I was shaken to the core by their distrust and ultimately their rejection of my feelings, of who I was and what I felt. At no point do I remember my mother being sympathetic or intervening as she had done for my brother.

Seen from the perspective of a sixteen-year-old, it was hard for me to grasp how something that felt so wonderful and made me so happy could be so wrong. No one I knew had a steady boyfriend or was experiencing the sexual awakening I was feeling except seniors in high school who were the only ones I could talk to. I was too young to understand why my emerging sexuality could so enrage and threaten my father. I came to feel like my world exploded, and I rebelled in the only way I knew how. I began to distance myself from my parents, not really speaking to them except for the basic niceties of everyday exchange. This went on for a few months. My brother wrote from college begging me to share some of my feelings with my mother. When Grant came home for spring vacation that freshman year, I wasn't allowed to see him, although we did talk on the phone; I saw him once at his parents' house when we were caught kissing in the closet. For Grant, my father's intense rejection of him was demoralizing and painful. My brother let me know that Grant was drinking a lot that vacation and later told me about exploits that ended in a disastrous freshman year.

My diary reveals a young teenager trying to sort out her feelings and her first love while coping with the parental assault. It speaks to my unhappiness and tears and my yearnings and infatuation but also to the tensions between Grant and me because of this forced separation. He let me know he was dating but that he missed me.

My father and I argued constantly; after I lost an election for class office at the end of my junior year, it took my father two days to tell me he was sorry.

Grant and I continued to write one another, but when he returned that summer, we were forbidden, after two years of dating, to see each other, something virtually impossible in such a small town with only one main street. Parental pressure remained fierce. My father was given to occasional explosive outbursts, and during one argument he slapped me and said he would disinherit me if Grant and I got married, at which point he and my mother began to cry and I became hysterical. I suppressed all this completely, the anger and the trauma. Only my diary reminded me of some of the details.

During that summer Grant and I managed to talk to one another and see each other occasionally. He would wait outside the small department store in Spring Valley where I sold clothes to say hello and, somehow, we stayed strongly connected. There was a bond neither one of us wanted to sever. But my father remained obsessed, following me around. One day, to my horror, I saw him hiding behind a streetlight after I left my summer job. This on and off drama continued over the summer and included a family explosion that left my brother crying uncontrollably and me frightened by his emotional state. Finally, at the end of the summer, Grant and I were able to spend some time with one another before he went back to college. I understood there was no way our romance could last, because my parents—and even my brother by then—had declared war on Grant.

During my senior year of high school, Grant and I continued to write each other, although less frequently than the year before. We remained supportive of each other's future, retaining a sense of the importance of our connection, however thwarted. Although I dated and kept busy, he continued to occupy my thoughts. Grant sent me letters in care of my high school because we were no longer allowed by my family to communicate. I still have a few of these letters and they remind me that despite all odds, Grant and I did

share something special. During the late winter of my senior year, when we were no longer dating, he could still write, "I'll never know love like we had again—unless it's with you, I don't know why it is, but it is that way." In the same letter, he mentions a letter he received from my brother that was "short and to the point," noting, "I guess your family and I will be at war forever." Grant and I still had some contact during the first semester of my freshman year at college and saw each other for the last time that Christmas, when the break was final. I have no idea what happened to him.

This a bare outline of what transpired. At the age of fifteen and sixteen, I experienced love and passion for the first time. I deeply connected with someone other than my parents and brother, and this first experience was fraught with tension, punishment, paranoia, secrecy, and anger. Something that made me so happy became a traumatic experience. My heart was broken. My parents were good people but utterly unprepared to deal with a spirited teenage daughter, a daughter who had a strong sense of herself. My father was clearly possessive and jealous and felt a Freudian rage that showed itself again in my twenties, never adjusting to the sexual mores of the 1960s.

But this was more than thwarted first love. I absorbed a sense of being emotionally abandoned, especially by my mother, who fully supported my father's position. I also had to process the trauma of my father's irrational anger. I, who had been his "favorite one," was now the target of his wrath. I, too, who had always worked so hard and tried to please, had disappointed and not met expectations. My parents' dismissal of my feelings and their distrust—the fact I was being told in effect I couldn't be trusted with my own desires—was devastating.

Whatever the explanations, this drawn-out crisis had a profound effect on me. On some level I had reached a breaking point and felt I had to do something to protect myself. I drew an emotional

line between my parents and me, and my relationship with them as a child ended. I felt a distinct sense of rupture, of separateness, along with the determination I would not let them hurt me like this again. Somewhere deep inside of me, I was no longer their child to mold and control. This I remember with absolute clarity. While on one level, calm was restored to the household and I remained respectful, even obedient, I have a distinct memory of marking my separateness from them. I still loved my parents, but my childhood relationship with them was over. How well they understood this I don't know. It was very clear in my own mind. The next step would be to find a way to rebuild my relationship on more equal terms, on my terms. This would take years.

What I didn't realize at the time and what now seems so clear is how much I gave up, and the degree to which a part of me was buried: the assertive, strong part of me, my spirited self who owned her emotions and was capable of independent actions, had to go underground, at least partially, and be hidden even from my conscious self. The consequences of asserting my independence, of being a young woman who believed in herself and her desires, had been devastating. I had elicited fierce anger; I had been abandoned, denied, and punished. This episode fueled my insecurities for many years to come, and it would be decades before I felt completely comfortable allowing that spirited and forceful me to assert herself and be liberated. I also lost a youthful innocence, some joie de vivre, and I became much more serious and introspective. The irony of all this is in the years ahead my father urged me to be happier and more carefree, to smile more, like my friends.

I finished my senior year, dated and went to proms, won an important regional oratorical contest, and prepared for college. Because Nanuet was too small to have a high school, I attended a school in the neighboring town of Spring Valley (the same one my mother had graduated from), where I was immersed in a socioeconomically and ethnically diverse environment, with many families having moved from New York City to more rural communities north

of the city. In college, despite the deficits in my earlier education, I would be proud I did not have a sheltered, private school worldview. I spent the summer after graduation in Denver with my intelligent, beautiful, and supportive cousin Maxine and her husband, Fred, with whom I remain deeply attached. They were an anchor in the aftermath of the Grant episode.

5. I Am My Father's Daughter

Arriving at Goucher feeling insecure, I was challenged on many levels, struggling emotionally over most of the four-year period, although I had many good friends. The first year was difficult in part because I was not as well prepared as many of my classmates who had gone to private school. Undoubtedly, I also felt the pressure of proving my brother wrong and meeting my parents' hopes and expectations as well as my own. My English professor told me, "Your only problem, Miss Dorfman, is your complete inability to express yourself"—not a comment to bolster an unsure freshman. My response was to go to the dean, who tutored me herself. The next year I had the highest grade on the final exam in my English class and made the dean's list.

As I reread some of my letters to my parents written decades earlier, I was taken back at the intensity of the existential angst I felt and how affected I was by Sartre and Joseph Conrad. A whole new world of literature and philosophy and darkness opened up to me, and at some point, during my freshman year, I came close to a serious nervous breakdown. I had no idea how to cope with the depression I experienced, and depression, occasionally severe, would be a recurring event in my life. My parents were concerned, but their response best I can ascertain from their surviving letters was they just

wanted me to be happy, have fun, and not be so serious. That was not who I was at the time. I wrote them about my emotional state: "Right now I am wobbly, and my equilibrium is poor."

Goucher was not a good fit for me in part because it was a small, isolated girls' school where I had a limited social life that left me lonely and frustrated. The brevity of a ten-week tri-semester calendar did not mesh well with my inclination to embrace challenging subjects that demanded in-depth research. But at Goucher I learned to write, discovered art history, and realized I excelled in psychology, especially after my professor begged me to become a psychology major.

It was at college that I had my first overwhelming, ineffable experience before a work of art. I walked into a small room of Mark Rothko paintings (see color photo insert) at the Phillips Collection in Washington, DC, where the paintings were hung close together with the effect that they became the environment, luminous and ephemeral. I was stunned, so overwhelmed by the emotional impact of the color that I became unsteady on my feet and almost swooned. My professor, Lincoln Johnson, understood immediately; he came over to me and we looked quietly together. It was the most spiritual experience I had had to this point. I learned later that this was the first time a museum had devoted a room to Rothko paintings; Duncan Phillips later dedicated a permanent gallery to his Rothko paintings, intending it as a meditative space.

Not surprisingly I became an art history major. There were two particular high points that were defining moments for me as a student: I undertook an art history paper on the influence of Japanese prints on Vincent van Gogh, which was a ridiculously ambitious and precocious topic that so engaged me I even missed going home for Thanksgiving, my favorite holiday. My professor was astounded at my research acumen and the extent of specific borrowings I discovered. The second memorable project was a self-study course on Crete and Minoan art, from which I developed a passion for ancient civilizations I have never lost.

My letters to my parents from Goucher that first year reveal a continuing strain between us. As I reread them, I felt myself plummet down the uncomfortable rabbit hole of memory, from which I had stayed clear for so long. Trips home and phone calls could be fraught with tension and angry outbursts, some still having to do with Grant. But these letters also reveal a loving and appreciative daughter, happy my parents were traveling and enjoying a more relaxed time in their lives, and grateful for their generosity which, after my sophomore year, included a trip to Europe, igniting my lifelong love of travel. I finally wrote to my parents that I was not willing to take all the blame for how often we disagreed and the lack of understanding between us. I would take 50 percent of the blame, but my parents and brother needed to share the rest. What strikes me in these letters is how hard I tried to communicate with them and be an honest and good daughter. I tried to share my philosophical musings and feelings, but I also asked my parents to respect what I felt. I don't have their responses, but in a subsequent letter I finally pushed back and wrote them that I didn't want to be told what I should think or how I should feel, and I begged them not to ask for more than I could give. My father accused me of not loving him and demanded respect.

In another letter, I tried to explain that we needed to find a way to establish a more adult relationship, one on more equal terms. My father, especially, was not ready and couldn't fathom yet the degree to which, on one level, he had lost me after the trauma of the Grant episode. I don't think he could grasp what had changed until the summer after my first year at Goucher. I remember, painfully, seeing his face as this loss was slowly dawning on him. He was sitting in our living room club chair, and he closed his eyes in pain. It was the same chair I remember him crying in seven years earlier, after his mother died. I don't remember what was said, but I can look back now as a parent and a grandparent and understand that I must have broken his heart. And I am sorry. Despite it all, I knew he loved me and his hopes for the future focused on me, but at that time, I just couldn't be the person he wanted me to be.

My parents, especially my father, had such a hard time letting me go, allowing me to find my place in the world. Even in my mid-twenties I was still getting letters filled with advice; Dad even wrote me, rather astonishingly, that no man would ever love me as much as he did, and I should listen to him and smile more and be happier.

My father remains something of a paradox to me even now. One of the greatest gifts he gave me was the value of independent thinking about the world. I was never a follower, yet he was controlling. He could be emotional, and I suspect he harbored an inclination towards depression, yet he had trouble accepting that side of me. It was several years before Dad and I could rebuild our relationship. In his last years, I was able to share deep affection with him and was extremely solicitous over his health, and we began to grow closer. But I never knew him with the perspective of a mature and married adult, as I later did my mother, or understood him until now. I never doubted how much he loved me, which made everything more incomprehensible to my teenage self.

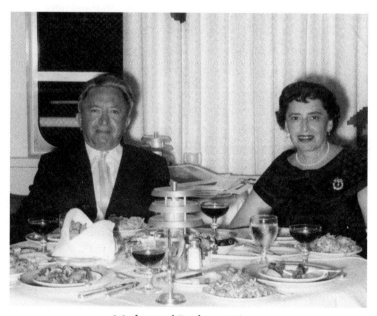

Mother and Dad ca. 1960

A few of my father's surviving letters reveal a level of intimacy he occasionally expressed with me, including his desire to provide for his family and give us financial security, something he never had. The environment I grew up in instilled my own entrepreneurial confidence; working hard like my father did forty years earlier, I would do the very same thing for my son and husband. These letters mean so much to me now because I can understand better his life's journey and what he had to transcend to succeed. One of the most moving, sent to me at Goucher, is from an opening night for his favorite opera, *Tosca*, starring Renata Tebaldi. From standing room at the Metropolitan Opera to hear Enrico Caruso in his twenties to opening night seats in the orchestra, he had finally arrived, and he was overwhelmed with emotion as he listened to his favorite opera. What a beautiful moment to have shared.

> It was a night of nights, to be remembered by all but to me as long as I live. To me that night had a great meaning more than just hearing Tosca with Tebaldi. It meant at long last a fulfillment and a realization of a cherished dream that someday I too would "arrive" and have some measure of success. There I was in evening clothes sitting in the orchestra next to my well-dressed and charming wife. All about us were exceptionally well-dressed men and women, the great and the near great, and there was "Hermie" right in the midst of them. Through my mind flashed many events of my life, my struggles, frustrations but always a firm belief in my future, never for a moment losing courage. I was a little emotional that night and a mist formed in my eyes. I leaned back in my seat and relaxed. I was starry-eyed at a dream come true.

Writing this memoir has allowed me to feel again real emotion for my father, to unlock compassion and love, and recognize how much he influenced the person I am today. I began to realize,

with genuine astonishment, the degree to which I am my father's daughter. My father and I shared many things: not only the values of integrity and hard work, but also a passion for gardening and opera, and the pleasures of photography. I still have his many cameras. He was sensitive and introspective and very responsive to the natural world, things I recognize in myself. He also introduced me late in his life to the pleasures of nice hotels and fine dining and good wine, all of which he exuberantly enjoyed. I, who had for so long suppressed so many aspects of my childhood and youth and even the town where I grew up, finally understood just how much of my parents and their values I brought forward into my adult life and the degree to which their history shaped mine.

After retiring from the State of New York in the early 1950s, my father opened his own engineering consulting firm, which at its peak had fifty-five employees. He secured several major contracts, overseeing the construction of the New York State Thruway in Westchester County and the complicated interchanges leading to the Tappan Zee Bridge. He was intensely ethical and trustworthy, something he conveyed in his manner and his actions, and which my brother and I came to share. I am certain this helped account for his success as a consulting engineer. My father was modest and unassuming in his success and generous with his good fortune. Having finally enjoyed financial security, he was able to give up some of his demons and begin to relax and approach the world with a more open, adventuresome mind, especially when he traveled to Europe and the Caribbean. In so many photographs, enjoying the beach or dinner with new friends, he seems to have recaptured some of the joie de vivre so evident in his youthful snapshots, relaxed and smiling, so different from the father of my teenage years. I wish I had known and could have enjoyed more of that side of him.

His capacity for great warmth was evident on a trip to the Virgin Islands in 1958. Arriving a few days before my mother, who

stayed back because I was sick with the flu, he found their hotel overbooked and was bumped to another establishment. The same thing happened to a young honeymooning couple who were warmly greeted at this second hotel by a man in an old-fashioned tank undershirt and shorts who showed them to their room. They thought he was the owner, but it was my father, lonely for company. He took them out for dinner at a beautiful mountaintop restaurant, and thus began an extraordinary friendship between Pearl and Seymour Moskowitz and my parents. This friendship eventually included me and developed over the years into a deep familial bonding that I still share with them sixty years later, a continuity that now extends over four generations to my son and grandchildren. Their memory of Dad helped me remember the warm, kind, extroverted, cultured, and generous man he was in his later years.

Dad suffered two heart attacks sometime in the early 1950s and died of heart failure in 1968 at age seventy-two, when I was twenty-seven and my mother was only fifty-eight. He was buried in an orthodox Jewish cemetery near his mother and father and my mother's parents, and where, later, I would bury my mother and brother. My mother was upset he had such a simple pine coffin, but this accorded with orthodox beliefs. It was the first time I experienced death as a stone wall one could not go through. Leaving the cemetery with Pearl and Seymour, I cried, "We can't leave him there alone." Later we sat Shiva, our house filled with food I didn't want to eat. I recovered relatively quickly, remained attentive to my mother and brother, and went on with my life, eighteen months later meeting the man I was to marry.

But my mother and brother grieved intensely for years—pillars of grief, together, in ways I never participated. My brother, for a period, was inconsolable, his reaction extreme and pathological. He cried constantly for weeks and even months, and my mother was left to take care of him, putting aside her own overwhelming grief. I was somehow in the middle, trying to help them both. My mother had known how hard losing our father was going to be for Bobby. She

told me later that after Dad died, she waited some time before she went to the "apartment" upstairs where my brother lived to tell him, she dreaded his reaction so; she knew it would be extreme. When my brother was most stressed, I sometimes found it easier to talk to him through our cats. This was particularly the case after my father died. Speaking through my cat, Carlotta, I would ask him how he felt, and, by stroking her, I would relay to my brother how much I loved him, that I was there. And he could in turn tell me things and stay connected.

My mother was to live another thirty-four years and managed remarkably well alone, traveling and enjoying a full life. She moved to her Fort Lee apartment in 1969 and enjoyed going into New York for the opera, ballet, and museums. She and I were able finally to develop a close and mutually supportive relationship. Remarkably we never discussed the Grant episode. I came to rely on her and trust her utterly through my marriage. She was always available to Bill and me, incredibly generous with herself, and took care of our son, David, on many occasions. She spent a great deal of time with us, and my friends enjoyed her for her warmth and the degree to which she pitched in to make them feel comfortable. She, too, shaped me by example as a resourceful and exceptional cook, by her interest in science, and through her willingness to take care of everyone. She was loving and giving to her family, an adored aunt and great aunt. I am not sure I could have managed without her.

Mother eventually moved to Washington, DC, in 1994, living in an apartment two miles from my husband and me. Independent and rarely complaining, she had the common sense to know when it was time to stop driving. In her last years, as dementia took over and I moved her to an assisted living facility, she still always recognized me and was sweet and gentle. It was incredibly difficult to see this extremely bright and independent woman so diminished but trying very hard to hold on to her dignity. As I gently stroked her hair and hands, my mother died quietly, knowing Bill and I were there with her. I kissed her and said goodbye and felt deep sadness, but I also

felt we had achieved peace with one another. I had taken good care of her and she of me, and I had no regrets.

Her funeral in 2002 was the last time I have been back to Nanuet; that same day Bill and I visited the house where I grew up. In the orthodox cemetery where my family is buried, we had a quiet graveside ceremony, joined by my brother's children, Colleen and Tommy, as well as Bill and our son, David, and a few cousins and some of their children in attendance. The weather was warm, but late autumn was clearly in the air. Dirty brown and yellow leaves blew about, and the ground was still moist. The rabbi's voice chanting quietly, my life was very much elsewhere, yet my entire family rested here. As we drove away my husband slowed the car and commented on how beautiful and quiet the cemetery appeared. As I looked out the window at gently rolling hills and the wooded setting in late fall, with a few leaves still clinging to branches and patches of grass still green, I was reminded of the rural area of my childhood and my walks in the woods. I felt more peaceful, comforted by the thought of my family together, part of the landscape where they spent most of their lives.

PART TWO

The Gift of "Seeing"

A Life in Art

.

6. On My Own Terms:
New York, the Critical Years

In college, where I learned to think and write, I discovered three incredibly important things about myself. I had an emotional intelligence and was psychologically aware; I had perseverance, an ability to work hard and achieve almost anything I wanted; and I loved art history and was a visual learner. When I graduated Goucher, I knew I wanted to do something special with my life. I wanted to contribute.

I initially spent six months in Denver, fell briefly for an actor, and by early 1963 shifted my life to New York City, where I worked as the assistant to the editor-in-chief of a paperback publishing house, Popular Library. My apparently very sexy phone voice was highly envied by my boss's colleagues. I was probably working in an environment not unlike that featured in *Mad Men*; my boss was no stranger to a three-martini lunch. New York in the 1960s was an extraordinary place to live, especially as a young woman interested in the arts. I had gone to Manhattan frequently during my college years, so I quickly settled in, initially rooming with a Nanuet friend. Within two years I rented my own studio walk-up on East Seventy-Eighth Street between First and York Avenues, which I shared with

a gorgeous cat, Carlotta, the first cat that was totally mine. I love cats, and I particularly loved this huge, crazy cat who was fiercely protective of me, once attacking a date whom she rightly perceived as on the verge of being predatory. I turned my small, light-filled apartment into a cozy and artsy space with colorful rugs, Matisse and Museum of Modern Art posters, and my grandfather's rocking chair, which I took everywhere with me and still have.

I was attracted from the beginning mainly to the art scene and began to frequent art galleries like Leo Castelli, then still uptown, and spent hours at MOMA and the Metropolitan Museum of Art, revisiting time and time again favorite artworks. I met people like Marsha Tucker who would become leaders in the contemporary art world in the decades ahead, and occasionally mingled in the bohemian atmosphere that still permeated Greenwich Village. Although I was aware of the weird mixture of major art figures and prostitutes hanging out in the lobby of the Chelsea Hotel and the drug parties in the Village, I experienced this world mainly at the fringes, in part because I was not into drugs.

During these early years in New York I began therapy with my parents' blessings and financial help. I went because I couldn't shake my recurring depression, a darkness that would come upon me that left me feeling so lost. I saw Dr. Schattner for two years, a kindly and very wise older man who took copious notes and was remarkably good for me. A Freudian psychoanalyst with a heavy German accent, he helped me revisit my childhood, my neediness, the trauma of my first love, and the emotional break with my parents. But I could never conjure up until now the depth of the sense of loss and abandonment I experienced, and I never made the full emotional breakthrough we both would have liked. I did emerge, however, a remarkably integrated person, grounded and centered, and while still subject to periodic depressions, I never lost that sense of my strong inner core. I was ready to embrace life and explore the world without risk of censure.

New York was exhilarating and sometimes frightening. During this period, it was a city of high crime, where almost everywhere

could be a no-go zone. One didn't venture into Central Park, one of the most beautiful urban parks in the world, because it was so dangerous. I escaped being attacked but was robbed several times; during a transit strike my apartment was trashed with cereal boxes emptied on the floor as someone desperately looked for cash. A *Life* magazine issue about crime in America featured an area two blocks from where I lived. A friend of mine was pulled between two subway cars and almost raped in broad daylight. I saw a man crouched at my fire escape window just a few weeks after two young women were murdered in their apartment on the Upper East Side not far from where I lived. I was so terrified I could barely call the police. We all had stories to tell, and when I walked home from the subway after dark, I always walked in the middle of the street.

The 1960s was a tumultuous and divisive decade, and in New York we were living in the middle of it. Things moved so fast that it was hard to absorb the magnitude of the societal change taking place and understand the full impact of what are now iconic images of national trauma that flashed repeatedly before us in newspapers, magazines, and television. It was the decade of the civil rights movement, the March on Washington, the Harlem riots of 1964, the Watts riots of 1965, and the tragedies of President Kennedy's assassination and later of Martin Luther King and Robert Kennedy. There was the horror of our involvement in the Vietnam War, the many war protests, and the Kent State massacre, the mass murders of eight nurses in 1966 in Chicago, the Mason murders in 1969, and the riots at the 1968 Democratic convention. 1968 has been referred to as a year of seismic and political change across the globe. It was also the year my father died. Looking back, I wish I had been more of a political activist, but I was certainly politically engaged and had the sense I needed to remain strangely vigilant. The "flower children" and counterculture of Woodstock and Haight-Ashbury, all part of the zeitgeist of the late 1960s, while present, were different from New York's more intellectual and bohemian challenge of the status quo.

When I think back on this period, I am amazed at what I was exposed to and experienced, and how worldly, in the best of ways, I became. It was a critical period of coming into my own and finding myself. I reveled in my freedom and emerging sense of identity, of living on my own terms as I sought my place in the world. It was also for me a period of sexual awakening. The birth control pill and the sexual revolution dramatically changed the mores of my generation, and many of us enjoyed a freedom not possible even a few years earlier. It was a long time before I allowed myself to feel the kind of passion that had so thrilled me with Grant. I discovered that while I was in no way voluptuous, men found me very pretty and desirable and genuinely liked me. One boyfriend told me I was the only girl he knew who looked better without her clothes on. I had long dark hair and great legs, and my classy and stylish bohemian dress reflected a bit of a free spirit and that I was part of the art scene. I didn't always have the best taste in men and even fell for an Israeli art history graduate student who told me he worked in counterintelligence, which is why I couldn't reach him. He always brought me one long stem rose, which was terribly romantic, and of course it turned out he was married. He cared enough, however, to come to my house in Nanuet after my father died.

New York was also a time of cultural immersion. My parents had two different season subscriptions to the Metropolitan Opera, and I was the frequent beneficiary of their tickets, especially when they were in the Caribbean for the winters. Sitting in orchestra seats, sometimes twice a week, initially at the old Met at Thirty-Ninth and Broadway, and then at Lincoln Center beginning in 1966, I heard some of the most important opera singers of the day. I cried every time I saw *La Bohème* and, on one occasion, witnessed an unheard-of standing ovation after Richard Tucker's aria in the middle of *The Flying Dutchman*. I came to love opera and how it had the capacity at its best both to reach me on a profound emotional level and evoke intense pleasure.

Over the next decades, I would return to the Metropolitan Opera many times, enjoying extraordinary performances with my

mother. On one occasion we heard Luciano Pavarotti, Joan Sutherland, and Marilyn Horne sing together the entire act or scenes from several different operas. It was probably the most beautiful singing I have ever heard in my life, and after the applause had quieted and the curtain closed for the last time, almost no one moved from their seats. I became a Pavarotti groupie, even going to Modena, Italy, just to see his villa, and with my husband and young son watching in amazement as my hands shook so much, I couldn't take a decent picture! One evening I was thrilled to sit in the front row of the orchestra at the Metropolitan Opera, one seat away from his father.

After a few years in New York and one serious relationship, I was ready for my next step, graduate school in art history. I knew I wanted to stay in New York, and rather than accept an offer from the University of Pennsylvania, I risked a provisional acceptance at Columbia University, contingent on my performance in a semester of courses. I took the Seventy-Ninth Street crosstown bus and subway up to Columbia almost daily and worked hard, impressed my professors, and was accepted. I embraced my time at Columbia, which had one of the best art history departments in the country, and was able to study with some of the great art historians of the day and be exposed to different methodologies, honing my skills as a scholar.

My area of concentration was nineteenth- and twentieth-century art, drawn as I was to Cézanne, Matisse, and Picasso and to Rothko and Jasper Johns and the emotive power of color. They each tested the boundaries of art making, infusing their work with a personal iconography and psychological tension. I also studied classical art and the art of the ancient Near East with renowned professors Otto Brendel and Edith Porada. I sat mesmerized as they instilled in me an intellectual fascination with the ancient world that deepened over time and a way of thinking about visual motifs, especially sculptural, that can transmigrate across cultures and retain their emotive power.

I had found myself, had focus and purpose, and was exhilarated. It is hard to overstate just how much I enjoyed my classwork; I can

transport myself back in a flash to that student again. I embraced the pleasures of cross-disciplinary research and found great satisfaction in opportunities for deep immersion and discovery. I spent hours in the Near Eastern study room at the New York Public Library, looking at images of Sumerian cylinder seals from ancient Mesopotamia circa 3500–2600 BC (see color photo insert). I was absolutely fascinated by how such a small transactional object, used like a signature, could be so beautifully carved and decorated with characters and figurative scenes that convey meaning, carrying myths to distant parts of the ancient world.

I excelled as a graduate student, and professors encouraged me to get a PhD. I was thrilled when one of my master's advisors, Lewis Hawes, told me my thesis paper on "The Deluge in Romantic Art" was one of the three or four most brilliant in his years of graduate teaching. I will always be grateful for those years. How I found my way to them still seems like a miracle. It was a transformational experience, an intellectual high point of my life, and a defining moment in my identity and sense of purpose.

I had several close friends in New York, but my best "date" and friend was Linda Warren Field, whom I met at graduate school in 1967. We were two attractive young women, confident in our femininity and our independence, savvy and sophisticated. We probably flaunted our sexuality, but we were never foolish in terms of our safety, and we embraced a spirit of liberation before the feminist manifestos took hold in the late 1960s. We shared a love of cooking and great food and enjoyed long dinners, sipping wine and eating at some of the best restaurants. We were a bit of a phenomenon in those days, as young women just didn't dine out together at nice restaurants. After being seated near the bathroom or the kitchen door, we learned not only to request but to nicely insist on a good table. We enjoyed this sense of equality.

Linda and I would prowl New York galleries almost every weekend, drawn especially to the extraordinary printmaking taking place and absorbing the visceral energy of the art scene. This was the

early heyday of Andy Warhol's The Factory, and we were certainly aware that we were living at the center of an important moment in avant-garde and pop culture. We saw at MOMA two major exhibitions of contemporary printmakers and understood that what we were looking at in art galleries would soon be defined as significant—we just didn't have the money to purchase prints by Robert Rauschenberg, Jasper Johns, Kenneth Noland and Frank Stella. While cataloguing the collection of Carter Burden and his wife, Amanda Paley, a not uncommon job for graduate students, I came upon Jasper Johns' recent color print series *0 through 9* in their baby's room; I so desperately wanted to collect contemporary prints.

I was incredibly fortunate to be living in New York and have access to the Metropolitan Museum of Art and the Museum of Modern Art. I frequented the Met where, in addition to ancient art, I was particularly drawn to Cézanne and how he used multiple perspectives to capture the essence of his subject, the intensity of his struggle so evident in his expressive brushwork. I can't look at a bowl of peaches and apples without thinking of Cézanne and how he captured their beauty and gravity, using patches of brilliant color to build up form (see color photo insert). At MOMA, I explored the meaning of modernity and contemporary art and the context for the New York School of painting, but it wasn't until MOMA's 1966 exhibition of sixty-four Matisse paintings that I truly discovered Matisse, captivated by how he conceptualized light and his daring compositions and expressive use of color. Over the next few years, I returned frequently to look closely at the Modern's Matisse holdings, trying to understand why they were so revelatory to me, especially *The Piano Lesson* (1916) and *The Moroccans* (1915–16) (see color photo insert). Decades later, memories of his brilliantly colored and radically simplified Moroccan images punctuated my visit to Morocco, one of the most memorable trips of my life. It was only after experiencing the dramatic qualities of light and colors in North Africa that I fully understood one of Matisse's pivotal paintings from that period, *The Moroccans*. I recently read that after

his experience of Morocco, Matisse said he began "to use black as a color of light and not as a color of darkness. . . ."

Independent and curious, I traveled three times to Europe, visiting Paris twice and going to Belgium and Madrid, where I quickly learned from constant harassment on the streets that Madrid, unlike Paris, was not a good place for a young woman alone. I never left my hotel room after five o'clock even though I had to wait to 9:30 to have dinner. The Prado became my sanctuary and classroom, and here I discovered the brilliance of Francisco Goya as a painter. His *The Third of May 1808* (1814) (see color photo insert) had a profound impact on me as a student; the rawness in his portrayal of the horrors of war and the dramatic, close-focused composition encapsulated in a way I had never seen before the human tragedy of war, completely transcending the events portrayed. I understood greatness. I could not help but think as well about Picasso's *Guernica* (1937) still on view at the MOMA in the 1960s and how radically modern both images were.

Soon after I received my Master of Arts degree, I was appointed cataloguer of American art and decorative arts at the Metropolitan Museum of Art, beginning my life as a professional art historian. It was an exciting time to be at the Met as the museum prepared to celebrate its centennial in 1970 with a yearlong celebration of major exhibitions, including *The Year 1200*. It was also being inundated with major gifts, and I learned to handle amazing works of art and do condition reports and research on each object, ideal preparation for becoming a curator. I was so fortunate to begin my career there and met a number of leading people in the museum world. Curator John Walsh, who later became director of the J. Paul Getty Museum from 1983–2000, asked me to write an article for the *Metropolitan Museum Journal* on an early James Whistler sketchbook, my first scholarly publication.

By my late twenties I was grounded, sophisticated, and a little unconventional in a nice way, and some described me as the girl with the wraparound smile. I was immersed in the New York art world,

working at the Met, hanging out at MOMA, meeting interesting people, and taking courses toward my PhD at the Institute of Fine Arts, NYU, just across the street from the Met at Seventy-Eighth Street and Fifth Avenue.

The Met paid for one course a semester, which I transferred for credit to Columbia University. The spring semester of 1969, I took a course on American art after 1945 with William Rubin, who had recently been appointed chief curator at the Museum of Modern Art. This was the same course Marsha Tucker walked out of during the first class because of his comments about the artist, Nancy Spero, whom she knew well, ultimately leaving academia behind. For me he was a brilliant lecturer, and it was a singular pedagogical experience. I came to understand how the synergy of a group of artists working together, sharing influences and experimentation, could evolve into a new way of making art. This course would later influence my thinking for my exhibition *The Fuseli Circle in Rome*. As part of the final exam, we were shown slides of fifty works of art and had to identify the artists. I was the only student who got all the answers right, receiving an A+ in the course. Rubin asked me to take his seminar on Surrealism the following fall, something I hadn't planned on but accepted as I was thrilled and honored. It was in this seminar that I met my husband, Bill, who likes to say I was in the class because I was pretty and hot, since Rubin was known to be something of a womanizer. I may have been hot, but I also had the gift of a great eye. I could make connections and identify artists with a clarity that harbored no uncertainty.

I fell in love with a man who embraced the intellectual life I so desired but who was also funny and irreverent. He had a gentle side and a wonderful sense of humor that appealed to me, and we shared so many similarities in taste and interests and values. Bill and I came from very different backgrounds, which I think we both found appealing. We first talked in the library at the Museum of Modern Art when he asked me to join him for dinner. We went across the street to Scribner's Bookstore, and, as we walked up the

With Bill

spiral staircase, Bill was angling for a good look at and up my legs. It was miniskirt era, which I certainly embraced. I turned around and said, "I don't believe you!" He flashed a smile. He was very handsome, and I just laughed. Before dinner, I needed to feed my cat, Carlotta, and ended up cooking for Bill. He has been part of my life ever since. Carlotta, who never liked any of my dates, fell in love with Bill. I would come home from work to find him asleep on the floor with Carlotta nestled in his armpit. Bill became something of a legend at the Institute. For his qualifying exam after he transferred from Princeton to enter the doctorate program, the panel of professors mistakenly gave him an oral exam. He passed with flying colors and two years later didn't have to take his scheduled orals.

We had a wonderful time falling in love, expanding our circle of friends and frequenting museums, sharing what we saw and how we looked at art, and our different interests. At MOMA and a few of the galleries on Madison Avenue we looked at Picasso's graphic works from the 1930s, drawn as we both were to his complex and private mythology and the beauty of his richly inked and brilliantly executed prints like *Minotauromachy* (1935) and the hundred images comprising the *Suite Vollard*. Bill also opened my eyes to

the intimacy and beauty of old master etchings, which he had begun collecting as a graduate student. On impulse, filled with the happiness of our time together, I purchased the *Bacchanal with Minotaur* (#85), from the *Suite Vollard,* with money I'd received from an Israel bond. Eight months later Bill bought beautiful impressions of Picasso's magnificent two sheets comprising *Dream and Lie of Franco* with money from an Institute of Fine Arts travel grant, the beginning of our collecting art together. Irresponsible, perhaps, but it thrilled us both to be able to look at exceptional impressions on a daily basis. A decade later we had to sell them to keep a roof over our head.

Bill spent most of his time in my small studio where, despite my tiny kitchen, I cooked elaborate meals for our friends and for our favorite Institute of Fine Arts professors, Robert Rosenblum and Gert Schiff, with whom we shared an unusual closeness for decades. I devoured Julia Child and Michael Field cookbooks and waited impatiently for the weekly *New York Times* recipes. I focused mainly on French cuisine, experimenting with everything from duck à l'orange to Cornish hens with a pistachio and glazed apple stuffing flamed in Calvados, to pureed peas delicately seasoned with browned butter, nutmeg, and a touch of sour cream. My favorite desserts were from the *New York Times,* a chocolate mousse steeped in cognac and a Brandy Alexander pie.

The kitchen was and is my milieu, and I bring to cooking a confidence that allows for improvisation. I am not easily rattled, and while I am an avid collector of recipes, I rarely follow them exactly; cooking for my family and friends continues to give me great pleasure, especially with today's open kitchens. In 1970, good produce was easily accessible because York Avenue, near my apartment, was like being in a tiny Parisian neighborhood, with small green grocers and a fantastic butcher shop that could do every fancy cut you wanted. Nearby there was also a bakery and a great wine store, while Bloomingdales supplied the au courant cookware.

Bill and I married a little less than a year after we met. I would have been happy to marry in Central Park or my mother's apartment

in Fort Lee, New Jersey, which had sweeping views of the Hudson River and the Manhattan skyline, but it was important to Bill's parents that we have a more traditional Christian wedding. My mother, ever the creative problem solver, came up with the brilliant idea of our getting married at the Union Church of Pocantico Hills, a small sanctuary decorated with stained-glass windows by Chagall and Matisse honoring the Rockefeller family, the rose window being Matisse's last work before his death. We had helped catalogue David Rockefeller's art collection, and his curator arranged for us to be married there. Nestled in a rustic setting, the chapel is a beautiful and intimate space. I didn't stress over the gown or the flowers, and we kept the ceremony simple; Bill and I walked in together through a side aisle, with light streaming through the colorful windows. We were married by a minister, but at the end of the ceremony, Bill stepped on a glass, a ritual that honored the Jewish tradition. And two families were joined. An elegant and delicious cocktail reception followed back in Manhattan at the Carlyle Hotel, where we happily cut our wedding cake to reveal chocolate layers, a touch of unconventionality I insisted upon.

I am not sure at the time that I realized just how transformational a moment it was. Marriage was important to me—I needed that anchor. I married someone who would become an art history professor; this was the life I wanted. I had married into a new family that I came to love deeply, and they would be an integral part of my life in ways I could barely fathom in 1970. Marriage also opened for me another world of southern manners and mores that I knew nothing about and was not always comfortable with. What was amazing, and to their enormous credit, is the fact my mother and Bill's parents immediately embraced one another with respect and affection. In the years ahead, they forged a loving partnership that helped all of us through genuinely hard times.

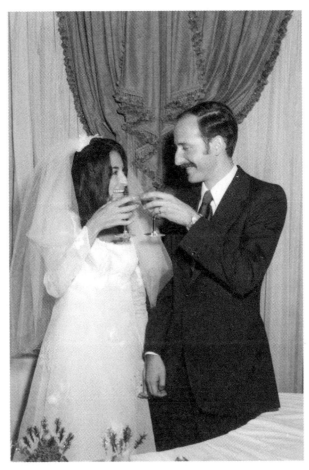

July 12, 1970

7. A British Residency

Bill and I spent the first years of our married life in London, where he researched and wrote his dissertation on the Irish artist James Barry (1741–1806), whose six large murals at the Royal Society of Arts in London form the most impressive series of history paintings in Great Britain. We flew first into Glasgow, where I finished my Whistler research and was quickly introduced to how different our life was about to become. The temperature in Scotland that June was hovering around forty to fifty degrees, and the only way to keep warm was by adding shillings to the small heater in our hotel room. We rented a car and headed to romantic castle ruins and the rugged beauty of the west coast and Scottish Highlands, but impenetrable fog diverted our plans. We ended up on a one-lane road going north, where we were soon hijacked by a band of gypsies. I cowered in the locked car while they syphoned our gasoline and left us to proceed along this isolated road shrouded in heavy mist, with no idea if we had enough gas to get to the next village. Miraculously, we ended up that evening in a lovely inn in Inverness, where we sat in the lobby before a fire, two freezing, shell-shocked Americans, barely able to talk until a kind Scotsman offered us our first taste of Scottish single malt. It was glorious! The next morning, we left for Edinburgh, stopping, on the way, at Blair Atholl, a stately home in

Perthshire, where we were astonished to see soldiers parachuting from planes and landing almost in front of us. It turned out that the Duke of Atholl has the only private army in the United Kingdom, and that was their annual day of military exercise!

After Scotland, London seemed terribly tame and not nearly as beautiful. For twenty pounds a fortnight we rented a third-floor flat in central London. The flat had no heat, and we survived England's damp and dreary winters with one electric heater. Adding to the "quaintness" was a kitchen so greasy that it took me days to get it clean, and a Scottish MP who, most nights, would stagger drunk up the stairs after midnight, usually falling against our door before he made it up the next flight to the top. Our compensation was that we lived across the street from Harrods and its legendary Food Halls, filled with British delicacies and the best cheeses, pâtés, breads and biscuits, and sweets I have had access to in my life. While we adjusted to a standard of living far below what we knew in the States, including frequent rotating blackouts, we were still startled when we discovered that a colleague had her bathtub in the kitchen and the toilet in an outhouse in the backyard. Our strangest culinary experience was not bangers or blood pudding, or fish and chips wrapped in newspaper with grease dripping on our clothes, but rather the chicken broth I made with a fresh chicken bought from Cobbs Butcher, one of the finest in London. What I didn't know is that these chickens were fed fish meal, and the broth ended up tasting like a quite disgusting fish soup.

Before I left for London, I had contacted without introduction Professor Jules Prown, director of the newly formed Yale Center for British Art, to see if I could be of assistance while we were in England. He interviewed me in the courtyard next to the Metropolitan Museum's library, and eventually I was hired to begin research on the philanthropist Paul Mellon's collection of British paintings, which, along with major holdings of prints and drawings and rare books, were to be gifted to Yale University, where a new center for British art, designed by Louis Kahn, was being

built. Little work had been done on the paintings beyond the basic catalogue information, and I soon learned auction houses and art dealers had been wildly optimistic about provenance, attributions, and identification of subject matter. My approach was to focus my research on groups of paintings, for example works done by British artists in India, country house views, or portraits and conversation pieces by individual artists.

This was an ideal job. Unfettered by office routines, I spent much of my time doing research in the majestic Reading Room of the British Museum with its huge dome inspired by the Pantheon and now converted into part of the Great Court designed by Sir Norman Foster. During breaks, while waiting for books, I could wander in the galleries of one of the greatest museums in the world. I spent hours at the Victoria and Albert Museum and in the British Museum Prints and Drawings Room training my eye to identify various artists' hands. In London, I had access to the immense resources of its libraries, auction house records, and photographic archives as well as the private library and photograph collection of Sir Ellis Waterhouse, director of the Paul Mellon Centre for Studies in British Art at Bloomsbury Square, where my office was located. I was immersed in British art and social history, trying to learn as much as I could about eighteenth- and nineteenth-century British painting and patronage. My hours of intensive looking and research began to bear fruit as I reattributed paintings and identified unknown sitters, country houses, and landscape views. I would sometimes discuss my new findings with Sir Ellis, one of the great British art historians and connoisseurs of his day, who was immensely supportive of my new attributions, adding to my growing confidence in my visual memory and eye.

I came to appreciate the special eccentricities of British art, but the truth was, it never truly captivated me in an aesthetic sense. There were exceptions, of course, like Gainsborough's sumptuous and exquisitely painted *The Honorable Mrs. Graham* in Edinburgh or Turner masterpieces including *The Burning of the Houses of*

Parliament, Norham Castle, Sunrise, and *The Fighting Temeraire*, as well as Constable's more loosely conceived landscapes.

During our stay in England, it became abundantly clear that travel was going to be a vital part of our lives together as art historians; it was essential not only to see original works of art but also to witness the context in which they were created, to experience whenever possible what an artist has seen. We traveled throughout England and Scotland trying to see as many museums as possible. We explored the British countryside for the first time much like eighteenth-century British artists and tourists before us; their reactions to its sublime views, ruined abbeys, country homes, and picturesque castles were memorialized in diaries and captured in landscape paintings and watercolors, many of which I was now cataloguing. We visited sites like Greenwich and Plymouth, favorites subjects of seventeenth-century topographical artists as well as country homes of dukes and earls. Not only did we find ourselves immersed in the wealth of their art holdings and history of patronage, but also we were able to get an intimate glimpse of a bucolic way of life centuries old, where fields were still surrounded by a ha-ha—a ditch-like space that keeps cattle from entering gardens, allowing for unobstructed views. I came to appreciate the special beauty of the English countryside and still thrill seeing lushly green, cultivated fields and country estates flying into Heathrow, reminded of the world of the impoverished land gentry and the extraordinary legacies many were trying to protect.

Occasionally during our travels, there would be wonderful surprises. After a visit to Salisbury and Stonehenge, where we were able to walk amid the Neolithic ruins without fences or crowds, unlike today's structured experience, we decided to go on to Winchester, staying at a charmless 1950s concrete-block Holiday Inn. Once in the room, I opened the drapes and there before us was Winchester Cathedral and Close, evocatively lit and beautiful, like some apparition. In the dark night sky, hovering to the right of the cathedral tower, was a full moon, a scene as romantic as any Joseph Wright of

Derby painting. It was astonishing. The next day we found ourselves driving along an old sunken lane almost enclosed by hedges clinging to the ground five feet above us, passing through tiny villages, some with thatched cottages that seemed preserved in a time warp. At one, near Petworth House, we had an amazing English tea set out on an oilcloth tablecloth. It was a rainy fall afternoon, and I can still see and taste as vividly as forty-seven years ago the hot scones, clotted cream, homemade churned butter and strawberry preserves, and tasty finger sandwiches I devoured with such pleasure.

In London we discovered antique markets and Portobello Road, and began collecting Art Nouveau tiles and occasionally pieces of early-nineteenth-century English china. In Bath we eyed a beautiful, museum-quality, late-eighteenth-century Japanese Imari bowl priced at fifteen pounds. When we gasped in astonishment at the low price, the dealer sold it to us for twelve! Bill also began to collect James Barry prints, eventually building over the decades a rare and important collection of the artist's work that is now housed in the Snite Museum of Art at the University of Notre Dame, where it was the subject of a major exhibition in 2016. We also made lifelong British friends including Clair and John Dean, who we met on a trip to Crete, and, through our research, we met interesting collectors, dealers, and British art scholars, although not all were thrilled by American scholars' intrusion into the field. Our stay also overlapped with other American colleagues, most importantly Sandra and Jonathan Brown, a renowned scholar of Spanish art, who remain among our closest friends today.

Living abroad was a memorable experience, and we were in England long enough to absorb another country's culture, idiosyncratic vocabulary, and eccentric ways. We got to know intimately a cosmopolitan city like London with its majestic parks, green squares, and iconic architecture, so much more livable than the claustrophobic streets of New York. I enjoyed the routine of taking a double decker bus to work each day, doing my best to get a front row seat on the upper deck so I could absorb London's unique

cityscape as the bus made its way past Hyde Park, Wellington Arch, and Green Park, down Piccadilly Road with glimpses of St James Palace and regal Regent Street before we turned into High Holborn. We walked all over London, tracing every aspect of James Barry's life, taking in magnificent architecture and old churches, traversing the city's beautiful parks, and immersing ourselves in eighteenth-century London.

We also traveled to Paris and southern France, where I saw the memorable carved Romanesque facades of the pilgrimage abbeys in Moissac, Vézelay, and Conques. Seeing these sculptural programs in their entirety with the effects of shifting sunlight on the carved surfaces was so different from the poor reproductions I had studied, a reminder again of how essential it is to be at the site, to see the original work of art. I would think of these astonishing abbeys and the religious belief they embodied decades later as we toured Ireland.

While in London, I began to think more deeply about how I approached looking at art and the distinctly individualistic character of an artist's brushstroke and modulation of color, how an artist's figure drawing can be, to knowledgeable eyes, akin to a signature. I began to focus on details, like strands of golden straw and luminous fabric in a Rubens painting, or the energy and anxiety imbedded in Cézanne's brushwork. Sometimes focusing on discrete passages allows me to enter, to begin to decipher an otherwise difficult painting. It also takes me close to the act of making art, allowing me to understand in a more empathetic way an artist's personal struggle. Though I didn't articulate it to myself at the time, I recognize now that in many ways I respond to art as I respond to the world, with my eye and my intuitive and empathetic nature. This gift of "seeing" was to lead me through some glorious visual experiences in my life.

8. Veering Wildly Off Course

After two years in London it was time to return to the States and begin a new life. As we flew into Kennedy Airport, the familiar skyline of New York was before us. I could even see my mother's apartment building near the George Washington Bridge and the sweep of the Palisades heading north along the Hudson River. We came back laden with suitcases filled with the beginnings of our domestic life together. We carried, carefully secured in bubble wrap, Art Nouveau tiles and pieces of early-nineteenth-century china and our budding collection of British prints, along with beautiful Georg Jensen flatware and Royal Crown Derby place settings we had bought with wedding money. Although I hadn't thought about how it would feel to return to the States, I was immediately taken aback by the presence of armed officers as we entered immigration, something I hadn't experienced in two years. Whatever strangeness I felt that afternoon in May of 1973 was relieved by the sight of my beloved cat, Carlotta, who immediately responded to my voice after two years away, crawling out from under my mother's bed to greet me. Our biggest adjustment was trying to understand the political upheaval that was taking place, arriving as we did when the country was in the grip of the Watergate hearings, something we had barely read about in London.

Bill had been appointed assistant professor of art history at Yale University, the very best place to be as a scholar of British art, and I was hired for a permanent position at the new Yale Center. Our plan was to move in mid-August to New Haven, where we found a large and sunny two-bedroom apartment, a walk-up on the third floor, close to the campus and on the same street as two of Bill's Art History Department colleagues, George Hersey and Walter Cahn. I looked forward to being reunited with our things in storage, including wedding gifts still in their original boxes, and was ready to indulge in the domestic pleasures of newlyweds, something we delayed two years. My plotline at the time was embarrassingly simple and conventional. We would buy a house, have children, and settle into academic life at Yale. By any standards, our future looked bright; we were a fortunate couple.

But things began to veer wildly off course before we even moved to New Haven. A suspicious growth, near my thyroid, had to be removed as soon as possible. It was a delicate operation, but fortunately my tumor was nonmalignant. This might have been a blip on the map but for several weeks later when my gynecologist told me—only after delivering a massive dose of progesterone because I hadn't had a period in over four months—that I was six weeks pregnant. Given the anesthesia and pain medication I'd received during the early weeks of my pregnancy, I was terrified about their impact and worried throughout the pregnancy. There was no question that we wanted children, but the timing was less than ideal as we adjusted to a new town and Bill began his first teaching position.

I decorated our spacious apartment in a comfortably modern style, and we soon settled into our new lives, beginning to discover the pleasures of an academic environment and a New England town near the sea. The Center's temporary offices were located in a nineteenth-century townhouse while the new building, Louis Kahn's last work, was completed. On his frequent trips to New Haven, Kahn often stopped by my desk for a long chat. I was awestruck

and remember him vividly. Decades later I watched, riveted, his son's beautiful film, *My Architect: A Son's Journey*.

Bill found the Art History Department and the Yale Center were welcoming and friendly, and his colleagues, especially Bob Herbert, Walter Cahn, and Vincent Scully, were supportive. Yale University was an intimidating environment to begin an academic career. Bill was understandably stressed as he prepared new lecture courses and navigated the dynamics and politics of academia.

Then suddenly in late fall, without warning, he began to have trouble lecturing. Initially he would occasionally become breathless, his heart racing in the middle of a lecture, but then the attacks increased in frequency and duration. Hyperventilating, he had to walk out of lectures to calm himself and regroup before he could proceed. We had no idea what was happening and were caught totally off guard. The fear of not knowing when the next attack would occur began to consume Bill. He was in a constant state of anxiety and increasingly depressed. We were terrified that after all of his years of training, and despite the fact he was a brilliant scholar, he might not be able to stay in his chosen profession. And all this was happening in a high-pressured, Ivy League academic environment.

Today we know that Bill was suffering from a not uncommon affliction: panic attacks related to public speaking, which can be treated with medication that immediately blocks the panic response. But this type of information was not readily accessible in 1973, and we had no idea what these attacks meant or what to do. At first, we didn't tell anyone, not even our parents. Bill felt like a pilot who had an acute case of fear of flying but somehow persevered, avoiding a crash landing by sheer determination.

All this was made more difficult by the fact that we were in a new environment with no support system and I was pregnant. Bill's anxiety and stress were obviously compounded by the new dynamic of impending parenthood. I would try to help by talking Bill through pre-lecture anxiety, but his fear of a devastating panic attack did not abate, and his sense of dread pervaded our lives. One afternoon I

sat on our couch, nine months pregnant, looking across the living room through the half-opened door of the hallway bathroom. My desperate husband was staring into the mirror, the medicine cabinet open. I needlessly feared he was close to suicidal.

Though my pregnancy was otherwise uneventful, there was little time to absorb how my life was about to change. Except for the women in my birthing class, I knew no one who was pregnant or had an infant. And I had neither the money nor the inclination to prepare a Martha Stewart–style baby room. We had a bassinet, a changing table, and a crib with a paper mobile I'd constructed from reproductions of Matisse paintings, one of which I had hung upside down, perhaps a metaphor for our lives at the moment.

I stopped working a week before my due date, but, as the baby was ten days late, I spent my days reading, knowing this might be my last free time for the foreseeable future. It seems odd to remember this so vividly: I sat all day on our living room couch, enjoying the warmth of the winter sun, reading *Portrait of a Marriage,* Nigel Nicolson's moving and candid account of the unusual marriage of his parents, Vita Sackville-West and Harold Nicolson. I followed this with Leslie A. Marchand's *Byron: A Portrait*, which I read alongside Byron's poems. So drawn was I to these intimate "portraits" and their reflections on British society, I have carried these books and the intensity and joy of this interlude with me for forty-four years, my memory of this time suspended between lives.

David Blake Pressly was born on March 27, 1974, weighing eight pounds, five ounces. His birth announcement, designed by a friend, had echoes of the sun burst from William Blake's *Albion Rose.* He was a beautiful and highly alert baby who chose not to sleep. Bill was in no position to help, and I relied on my mother to get me through those first exhausting weeks and months. I knew nothing about taking care of babies. There were times I would try to calm Bill before a lecture while nursing David in a large overstuffed faux leather chair, a strange conjunction of caring that left me sometimes overwhelmed and very lonely.

I slowly eased into the new rhythm of my life and cherished the peaceful times and intimate moments with David, especially when I nursed him in the quiet of the night. He would stare up at me with total contentment and what felt like adulation, and I embraced the sensual feeling of my milk letting down. Somehow in these first weeks I listened to my intuitive side and came to respect the individuality of this little baby and what he was trying to communicate. I became intensely attuned to him and developed a deep emotional bond that came from our intimate physical and emotional interaction during those first six months. I can still feel with pleasure the heavy weight of his sleeping body on my shoulder and see his silly smile when he played with his toys. He was an amusing, affectionate child, and I adored him.

Carlotta, our hefty, eighteen-pound other "child" with some wild cat in her, was less enthusiastic, her routine completely disrupted. At one point she chased me wildly around the bed while I stood on top of it, scantily dressed, holding David in my arms and screaming while Bill stood at the door laughing hysterically. A few months later, after a direct swipe across David's face while the two were sitting on his blanket, they made peace, a sight I captured in a photograph of the two of them staring each other down. My camera was never far away, saving memories in images of an adorable, funny, playful, smiling child loving his bottle, deeply engaged with his toys, and finding his environment an amazing playground. I found great joy as a mother seeing him test out his surroundings as he learned to stand and walk.

I returned to work part-time in September, six months after David was born, happy to have the stimulus of colleagues. Bill's panic attacks continued, although not as frequently as the previous year, and he began to see a psychiatrist. Then in late October of 1974 Bill became sick with a recurring fever that went on for weeks. His internist treated him with several rounds of antibiotics, but the fever kept returning, and Bill grew increasingly more exhausted. By mid-November I was terribly worried, and one night as I lay next to

him, listening to his labored breathing, I suddenly knew my husband was critically ill. It was near midnight, but I couldn't wait any longer. I called a friend who was not a physician, though in the medical profession. He told me to bring Bill to Yale New Haven Hospital in the morning, and he would make sure he was placed under the care of the hospital's best infectious disease specialist, Dr. Andriole.

Andriole didn't even wait for final test results to start Bill on an antibiotic drip. He had bacterial endocarditis, an infection of his aortic valve so severe that if he wasn't treated immediately it could spread to his other organs and brain. He had every classic symptom of the disease and his aortic valve had been destroyed, and yet his internist never even considered endocarditis as a possibility. The option of inserting a PICC catheter was not available in 1974, so Bill remained in the hospital for thirty days on a twenty-four-hour IV drip. His veins collapsed within a couple of weeks, and it was a form of torture as nurses struggled to insert the daily IV. I sat by Bill's hospital bed and we cried together. Thankfully, my mother and Bill's parents took turns helping to care for David. While Bill slept, I walked zombie-like in the hospital hallways, trying to absorb what was happening. A friend came to visit and just held me in his arms. I somehow managed to get through each day. I have a vivid memory of the day Bill came home from the hospital: lying on the bed, exhausted and ghostly pale, with David playing next to him and our poor cat, who had just had an infected tooth pulled that morning, collapsed on top of him. Our family was together again, but it felt so tenuous.

Bill returned to teaching during the spring semester while we waited for his Yale cardiologist to determine when his aortic valve should be replaced. Both of us were utterly depleted and stressed, and David, reacting to the tension, stopped sleeping. Contrary to what friends advised, I walked him around the apartment almost every night, determined to calm and console him. I had no time off and little sleep and daydreamed about getting sick myself so I could go to the hospital for a few days and no one would ask anything of

me. I was aware of my own melancholy and the sense that a certain joy and innocence had again been snatched from my life (echoes of my first love with Grant). I, too, had a lot of healing to do, and I went back to my old New York therapist.

Bill was clearly not well and had trouble walking up two flights of stairs to our apartment. Even so, it was hard for us to assess the degree to which he was getting weaker. My mother came for a visit and was shocked at how much he had declined in a month. It was her decisive action that got him into the office of a leading New York cardiologist, who immediately sent him to a brilliant young surgeon in Boston. She saved his life. Had we waited another few weeks, it would have been too late to operate because his heart was so enlarged it would have lost its elasticity.

Bill was one of the first heart patients to have a pig's valve replacement. I was so terrified the night before his surgery I began to hyperventilate, and Bill's brother, Paul, had to take me to the emergency room. My dear brother-in-law has since been by my side for every surgery, including my own; I am deeply grateful to him for his love and support and the continuity he represents in all our lives. Bill was so sick, but I tried to keep things in perspective: a young woman two rooms down from him was dying of cancer, her fiancé constantly by her side.

We stayed in a rented Boston apartment for three weeks as Bill slowly recovered, bolstered by David's joyous antics and his exuberant times in the bath, bubbles flying everywhere, and how much he liked to feed himself, smearing carrots and applesauce over his face and highchair. These were the images I clung to because otherwise my world was a blur.

This health crisis changed my attitude toward the medical profession and my relationship to Bill's health. I became a patient advocate and aggressive defender, determined to get Bill the best help possible. I was always nice and respectful, but I didn't flinch at asking questions of doctors, even though their defensive pushback has on more than one occasion left me in tears. In the years ahead,

I would battle physicians' arrogance and Bill's own passivity and ability to remain in denial when he was ill. I would read his medical test results and use my research skills to achieve at least a basic understanding of what they meant. My proactive position has saved Bill's life more than once and would later save my own.

To his enormous credit Bill slowly found his way to a cautious equilibrium both physically and psychically, and he returned to teaching in the fall of 1975, several months after surgery. Therapy helped him understand his panic disorder and better control his demons, but those first years took their toll. It took him almost a year following surgery to feel like himself again, and during that period he grew a bushy mountain-man beard and zoned out. It is shocking, even today, to look at photographs and see his haunted eyes within dark circles—the face of depression. Melancholy increasingly became part of his persona. He had been hit very hard on two fronts, and he was only thirty-one. We had been married less than five years.

9. Life on Lincoln Street: Motherhood and Scholarship

Bill's critical illness so early in our marriage changed both of us in profound ways, subtly and incrementally shifting the dynamics of our relationship, the balance of sharing, and how we cared for one another. When I think back to some of the choices I made and why I shouldered more of the burden than I needed to, I can see I was determined to do everything in my power to make sure the three of us would thrive. My family needed me. I was not good at asking for help (a trait I'd developed early), but I also had the inner strength and resilience and probably a selflessness to assume the role of taking care of my family.

I rarely showed anger, "protected" Bill and deferred to his needs, and was the organizer of our lives. This dynamic was never to change, and I came to be seen, and still am, as the linchpin, the person in our family who held it all together. Even today the house echoes with the cries of "Meema, Meema, Meema!" with the grandchildren and my son and my husband, half in jest, calling for me. But as roles shifted, I also got to call a lot of the shots, something I probably wanted. I am not sure Bill cared about this; all he really wanted to do was to research and write, and I let him do this.

The fall after Bill's operation, we moved from our apartment into a rented home, a charming 1875 wood-frame house with no insulation on Lincoln Street, a two-block street with beautiful old homes. Our life on Lincoln Street nourished us, and we became close friends with five young couples. It was a unique and special time for all of us who shared these years together. We created deep bonds with what were to become lifelong friends. Our home, our first house together, became the neighborhood gathering place for casual dinners and cocktail hour as well as more elegant fare. I would talk to my neighbors over the fence and our children played together; I finally had the special kind of friendship that can develop among mothers with young children, and a support system that expanded beyond Yale colleagues.

I am very proud of the way we picked up our lives after Bill's illness and learned to live more in the present and cherish our imaginative and joyful son. And we were fortunate to be living on Lincoln Street. Our neighborhood somehow encapsulated the best of what living in a small New England university town could be, with young professionals, beautiful old homes, distinguished professors, and easy access to good museums, cultural events, and lectures. Finally, able truly to settle into academic life, we began to enjoy the remarkable Yale community with its intellectual engagement and interesting students. Being part of an academic environment became part of my identity. After such a rough start, Bill eventually became more comfortable in the classroom and was a great teacher, much appreciated by his students at Yale.

Throughout Bill's illness and recovery, I continued to work part-time at the Yale Center for British Art, grateful for the understanding of my superior and eventually dear friend, Ed Nygren, who allowed me time when I needed to be with Bill. Ed and I authored the catalogue for *The Pursuit of Happiness,* the inaugural exhibition of the Center in the spring of 1977. The opening was a major event in the international world of architecture, this being Louis Kahn's last work, and of course in the art world, given the prominence of

Paul Mellon as a collector and as president of the National Gallery of Art. *The Pursuit of Happiness* was intended to highlight the depth and range of Mr. Mellon's collection and the importance of this gift to Yale University. Stuart Silver, who gained renown for his installation of the *Treasures of Tutankhamun* at the Metropolitan Museum of Art, where he was chief of exhibition design, was hired to design the installation.

Less than a year before the Center's opening, the director, Jules Prown, unexpectedly resigned to go back to full-time teaching at Yale. The new director, Ted Pillsbury, former curator of paintings at the Yale University Art Gallery, took over and began to place his own stamp on everything. My professional life took a dramatic and unexpected turn, and Ed and I along with other staff members were given notice that we would no longer have positions after the Center opened. Some positions were later filled by British curators, a dynamic that would ultimately affect Bill as well. The nastiness and paranoia that ensued over the following months was completely unexpected and deeply painful: Ted even threatened not to publish our catalogue, a challenge I fought him over. I tried to retrieve the typewritten manuscript from his hands, a moment of impulsiveness I quickly corrected when I remembered how much squash he played. In the middle of this malice and craziness, I was reminded of what was important. I came back crying from the office that day, and my sweet, sensitive, two-and-half-year-old son, who was totally attuned to me, said, "Mommy, sit down and let me read you a book." The irony of the exhibition's title, *The Pursuit of Happiness*, was not lost on me.

While I remained at the Center until the opening, I felt increasingly unmoored. With little emotional reserve left after the previous two years, there were days I wasn't sure who I was or what I wanted or, at my worst, if I even counted. But I realized that I did not want to relinquish my professional identity and reputation in the British art world, and, building on previous research, I presented a proposal to the Oversight Committee for an exhibition entitled *The Fuseli Circle in Rome: Early Romantic Art of the 1770s*. Perhaps

With David, 1976

because some members, including Jules Prown, were concerned by what had happened, my proposal was accepted, and I was given a stipend and travel expenses. I had a project after I left.

This was a huge undertaking, and, as I look back now, I am genuinely amazed at my resolve to take this on at Yale University, the bastion of the old boys' network at the time! In the decades that followed I have so often thought of my ambivalence about working and the conflict I felt around letting my more ambitious, confident, and strong side flourish, but now, as I look back to this moment and am honest with myself, I am astonished at how assertive and strategic I was. Despite my intellectual insecurity, I displayed a belief in my ideas, a willingness to take risks, and determination and focus. I was not going to fail in this. I also had my husband's complete support. Was this the first hint of the spirited teenage girl reemerging, if only briefly? Almost certainly.

The exhibition brought together an international group of artists working in Rome in the 1770s. Representing completely new research, it demonstrated how these artists worked closely together to develop a new, expressive graphic style. Both in their choice of subject matter and in their romantic self-portraits, they explored extremes of emotion, which was to become a central concern of Romanticism. I was able to reattribute a significant group of drawings and identify subject matter and common sources. Many of these artists were not well known, but seeing these works together was surprisingly revelatory and visually exciting; the artists' brooding self-portraits I installed on the opening wall added to the dramatic mood.

Writing the catalogue against an immutable deadline was intense. At one point I was so stressed my mother-in-law, who was the model of southern decorum but also an astute observer, said, "You need to go outside in the backyard and just scream." The critical pieces began to fall into place, and one evening I felt like I was hit by thunderbolts of insight, barely able to get all my thoughts down on paper. I can best describe this as a near out-of-body experience; I left my study drenched and reeling, but felt, if but for a moment,

I had touched the state of inspired genius these young artists were embracing. As I raced against the manuscript deadline, I explained to David, who was only five, that when we had a sitter, he couldn't disturb me unless it was very important. We were very close, and he would sometimes sit on the other side of the closed door and send sweet love notes under the transom: "I love you, Moo Kiss Kiss." I still have them.

It was thrilling to open the art section of the Sunday *New York Times* in September of 1979 and see that the lead article was a review of the exhibition by distinguished art critic Hilton Kramer, who described the show as "an exemplary exhibition." Later the poet and critic John Ashbery wrote in *New York Magazine* that it was "the very model of what a university art museum exhibition should be," adding, "the results of her meticulous scholarship are so consistently entertaining and revealing." A number of glowing reviews followed. This was a huge turning point in my life and in my sense of identity. I had overcome my intellectual insecurities and produced noteworthy scholarship, thereby gaining status in the world of academia and museums, which would be critical to my future. I even made peace with the director, Ted Pillsbury, who had fired me: he asked me to his office and thanked me for what I had done for the Yale Center and for him. I was surprised and gracious; we shook hands and remained cordial colleagues over many years. Bill has frequently commented, not always approvingly, on my ability to move beyond slights and offenses and not remain embittered. I can just let them go.

But not for everyone. I didn't forget the arrogant and condescending (and sexist) attitude of the new British curators. I wasn't even asked to participate in a symposium organized around my own exhibition except to give a tour! I finally fully absorbed the fact that my professional connections had been severed; the pain of this rupture lingered for many years and occasionally still reappears in nightmares.

10. Wearing My Heart
on My Sleeve

While I worked incredibly hard on this exhibition, I also enjoyed for the first time sharing the joys and pitfalls of motherhood with my neighbors on Lincoln Street and with other young women I met at David's preschool. For a brief period, I achieved a crazy, wonderful balance: baking bread, running, spending afternoons with my son, cooking nice dinners, and writing an important scholarly catalogue, all on my own schedule. Some might call this "having it all."

Becoming a mother centered me in new ways, and my capacity to "read" people astutely came increasingly to the fore. I am an empathetic listener, deeply attuned to the feelings of others. My first instincts are always what can I do to help, how can I make it better, and this urge to comfort extends not only to my family but to others as well. During our time in New Haven, I became increasingly aware that friends gravitated to me, grateful for my insightful side and ability to go to the heart of an issue, and for my wise advice. Bill has told me many times how important my emotional intelligence and psychological awareness has been to our marriage and our lives together. When I recently asked my New Haven friends Sally Tyler and Joanne Bailey what they remembered most about me, it was as a sympathetic listener who always had time for others. "You not only

took such good care of Bill and David but of all of us." This included helping an elderly neighbor, Brook, who was dying of cancer and whose children did nothing. I arranged for home hospice care, and, near the end, only my voice seemed to penetrate his coma, so hospice would ask me to see if he was in pain and he would shake his head no. After he died, hospice called me to see how I was doing. They considered me the family. Brook's death hit me hard, not so much about him; even though I had lost my father in 1968, this was the first time I had felt death in terms of my own mortality, and a sense of terror lingered for several weeks.

Years later in Washington, DC, I would take care of a friend, June Hargrove, who was going through a rugged protocol of chemotherapy for breast cancer, spending three days and nights with her every three weeks for several months. I still have my "Nurse Nancy" hat from a party that celebrated her health and my help. But making myself so emotionally available to people could also be physically draining, and it was becoming abundantly clear to many that I was trying to do too much. My father-in-law wrote to me years ago, "You give and give, and give and give, sometimes to your own detriment. Please be kinder to yourself." My son, decades later, also commented on how much I give to my friends and my family, how emotional I am, and he told me, not particularly as a compliment, that I wear my heart on my sleeve.

This desire to try to make things better, to absorb other people's emotions and be finely tuned to their needs, is central to who I am. I value this loving, giving side of myself, and I deeply trust my intuition; it has guided me throughout my life. My assessment of people and situations is, uncannily, almost always right. Looking back, I wonder if this willingness to be the caregiver, the fixer, to make myself, in effect, indispensable was my subconscious way of deflecting my own neediness, my own fear of abandonment. My therapist saw the needy person who wanted to be taken care of. I fear my young son may have as well. As Bill struggled, David and I grew increasingly close.

Life was not all about illnesses, work, and introspection. We enjoyed our friends and colleagues, explored the city and East Rock Park, had wonderful parties, and neighbors frequently gathered for drinks and conversation on each other's porches, watching our children enjoy their close friendships. During these years in New Haven we set up patterns as a family, one of the most important being annual vacations. We explored colonial sites in Connecticut and Vermont, including Grafton, where we stayed at a quaint inn and discovered in nearby abandoned fields seventeenth- and eighteenth-century gravestones carved with winged angels or winged skulls. Several summer vacations were spent at DeBordieu Beach in South Carolina, where Bill's parents were offered an oceanfront house for a week. Located adjacent to Hobcaw Barony, the former Bernard Baruch estate, we could walk for miles along this isolated beach. Nearby was Litchfield Beach with its saltwater marshes and spectacular bird feeding areas, which we would visit early in the morning or at dusk when the colors and reflections were so beautiful. I relished these opportunities for shelling, a lifelong passion, but most importantly the ocean has always been for me a siren song, as if being called by some deep genetic code. Walking along the water's edge, inhaling the salt spray, feeling the sea breeze, and watching the changing colors on the horizon is my form of meditation. The sea quiets my brain, lets me just exist and not think, and soothes me in profound ways. Decades later we occasionally still go back to DeBordieu and the coastal islands of Georgia, like Ossabaw and Little St. Simons, with Bill's brother, Paul, and his wife, Jane.

Traveling was something Bill and I would never give up, regardless of our finances, and our trips became essential interludes in the decades that followed. Photographs remind me of these New Haven years and our years as a family: David and me close or embracing and Bill beside us, forming a happy triad. As I lingered over these images, I was amazed at how beautiful and exotic I looked back then, not my memory of myself.

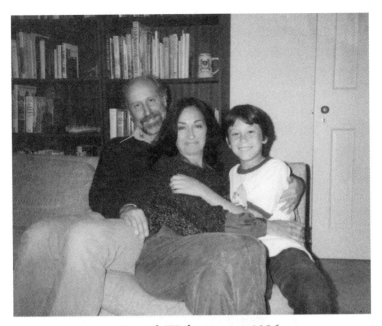

A triad, Washington, ca. 1986

Our time in New Haven is also when I think about Bill's parents and my mother with deep gratitude; we were so fortunate to have their support. While Bill's mother and I shared a loving connection over the years, I developed, in this first decade of marriage, a special bond with my father-in-law, William Laurens Pressly, founder of The Westminster Schools in Atlanta. When I married, he was an unexpected gift who came into my life. I sometimes like to say it was love at first sight, and despite the intersection of our very different backgrounds, Dad and I developed a profoundly close relationship. We were always honest with one another, and he greatly valued my candor and my moral compass. He told me he treasured our long conversations "because you always analyze situations and people so well." It is a testament to his flexibility and willingness to grow that he met my deeply open side with equal responsiveness, sharing a side of himself and a tenderness I am not sure anyone else knew. I am also physically demonstrative, and he and my mother-in-law liked to say that I taught the family how to hug.

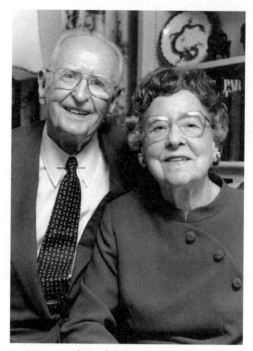

Mom and Dad (Alice and Bill Pressly)

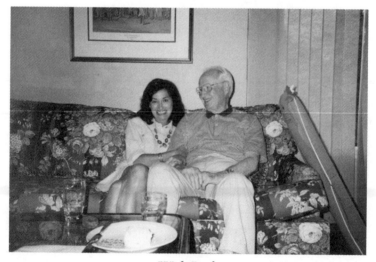

With Dad

Mom and Dad were enthusiastic about my cooking, and during their visits, especially over the holidays, I would sometimes cook them three or four gourmet meals in a row. I still have the menu sheets from some of these cooking extravaganzas! When we had a dinner party, Dad wanted to know every detail of what I was cooking and would call the next day to see how everything went. When we were together, he looked forward to making coffee for me in the morning, and we would share our scotch in the evening, a ritual we both looked forward to, sitting on the sofa waiting impatiently for the clock to strike five. He was a loving, proud grandfather and so enjoyed playing with David. He held David so tenderly in his arms when he saw him for the first time, and this little infant, with eyes wide open, gazed contently back. And later, he did everything he could to help David succeed when he moved to Atlanta.

I will always be so grateful for Dad's affection and support. Over the years he made me feel taken care of. He never replaced my father, nor did he try to, but he gave me an unconditional love and expressed a sheer uninhibited joy in my successes, and genuine pain and regret for any disappointments. His letters to me were often filled with his sometimes over-the-top, effusive praise, but they were also on the mark in terms of his assessment of me. Rereading some of them now, they still resonate. He worried and cared about me like I was his daughter. His openness to everyone about his affection gave me enormous pleasure. During this period of our life in New Haven and later in our first years in Washington, DC, Dad was a rock I could lean against. He cherished me and worried about me. I am strong and resilient and sometimes selfless, but I am not sure I would have had quite the courage or strength without him. I felt comforted when he put his arm around me or when I rested my head on his shoulder. He somehow provided me with the knowledge that I could always count on him, that he would be there and catch me if I fell. He instinctively knew that while I may be strong, I, too, needed to be taken care of. Likewise, he knew I was there for him always, and I would never let him or his family down.

In the end, I think of Dad as one of the great loves of my life. He died in 2001 while we were in New Zealand celebrating my sixtieth birthday. We talked just before we left. He had been seriously ill, his heart failing, and somehow we acknowledged in unspoken words that this might be the last time we would talk. I told him how much I loved him. My feelings were so intense I could barely talk, and my hands were trembling as I put down the phone. I think of him frequently, and to this day I miss him in ways that still make me ache. He died apparently watching the clock, very weak but waiting to see David one last time. David arrived as promised at 11:00 a.m., and Dad's heart stopped beating almost immediately. Bill and I were devastated and far enough away that it was actually a different day. I felt scared and overwhelmingly sad, and we flew back for the memorial service. I regret I didn't speak at his service, where many of Atlanta's leaders and Westminster teachers and graduates gathered to honor this great man and how, through his commitment to excellence and his moral fiber, he inspired so many in Atlanta. I wish I could have shared with them a more intimate side of William Pressly, to break through the formality of his civic leadership and reveal the unbelievably tender man and father. My last physical gesture for him was to join the family in sprinkling some of his ashes on his grave, a profoundly intimate and spiritual moment.

11. Competing Selves

In the immediate period after the Fuseli exhibition closed, I took on occasional consulting jobs and, for the first time in years, tried to focus on myself, both my emotional needs and what I wanted to do with my life, how I could contribute. My mind went off in many directions. My overwhelming desire to own a home consumed me; I so wanted to experience all the joy that comes with the sense of belonging to a place, a home in which our son would remember growing up. And, on a more intimate front, this would have been the ideal time between jobs and major projects to have had another child, but we did not, a choice we made as a couple and one we have reflected on many times. A major road in life was not taken, and I have often thought about what life would have been like if we had.

Weighing heavily in our lives was whether Bill would get tenure. His contract had been renewed for three more years (for a total of nine), but it was not until the spring of 1980 that we learned his position would not be turned into a tenure-track line. This was definitely a blow, although we were not totally surprised, given his earlier health issues. But I had been hopeful, especially since his first book, *The Life and Art of James Barry*, was being published by Yale University Press, and his major exhibition on Barry for the Tate Gallery in London was to open in 1983. These successes

and recognition helped him maneuver through a difficult period but could not mitigate our loathing for the politics of academia, especially the viciousness and pomposity that emanated from the Yale Center.

The next year was hard: I simmered with frustration, unclear about next steps. I railed at the gods and felt desperately trapped, sometimes wanting to flee the circumstances of my life. It was hard for me to think about next steps and chart a career path when I didn't know where we would be living. Depending on where we ended up, I wasn't certain if I still even had a career in art history. Given my psychological awareness, I contemplated going back to graduate school to become a psychologist. Not surprisingly, our uncertain future and money worries weighed heavily on our marriage, and we certainly were not in the strongest place in our lives together. It was during this period we sold our Picasso prints to cover expenses.

But I was also digging deeper trying to understand what I had come to think of as my competing selves. There was the me desperately wanting to nest and enjoy the conventional pleasures of domesticity, who was needy and vulnerable and wanted to be taken care of. But I was also aware that this side was beginning to share equal time with what I thought of as my other persona, the Nancy who curated the Fuseli exhibition and stood her ground, who was ambitious, focused, and talented. For the most part, this more assertive self remained hidden (was I afraid of competing with my husband?), but I knew "she" was tentatively knocking at the door and threatening my careful construct of myself. I was more conflicted than I consciously realized at the time. I also knew I didn't want to do anything that could negatively impact Bill's future.

Context is important here. Although by 1980, the drumbeats of the second generation of the feminist movement were slowly making their way into our collective feminine psyche, its impact, especially in terms of gender roles, was still marginal. For a while, I went braless and even took off my wedding ring, half-heartedly asserting a sense of my independence, although admittedly I was

the only one I knew who was doing this. Efforts to pass the Equal Rights Amendment were certainly raising awareness of the issue of equality at home and in the workforce, but, even in an environment like Yale, almost every woman I knew with children, except those with academic jobs, was still in a conventional "homemaker" role. Their careers were to blossom years later. The truth is I never delved deeply into feminist literature, in part because I didn't support abrasive feminist rhetoric or some feminists' embrace of a dress-down, anti-glamorous look. I wasn't conflicted about my femininity and reveled in my sense of style and the fact I was attractive. I never thought about it helping me or getting in the way; it was simply me.

It is not surprising, therefore, that while Bill was making inquiries about teaching positions it never occurred to either of us that we would move for anything other than for his job. Indeed, it was something I didn't even want to consider. I wanted Bill to succeed, and I wanted Bill to take care of me. But by the spring of 1981, we began to worry; there were few job openings in Bill's field, and, while two institutions expressed serious interest in Bill, nothing certain was on the horizon in terms of a tenure-track position. Neither one of us remember the details of our stressful and agonizing discussions, but we concluded that both of us needed to look for a job rather than risk the frightening possibility of not having a salary. We somehow agreed we would move for whoever got the best job first, but the reality was that we never talked honestly about how each of us felt or spent enough time strategically thinking what this might mean for the future.

Eventually we grabbed onto the first line we could catch, which was an offer for me to become chief curator at the San Antonio Museum of Art, a major position. The fact that we would move for my job was radical thinking for our time, and the truth is we stumbled blindly. On one level, Bill was relieved because he desperately wanted some time off, and I naively thought I was "liberated" enough to give him a year off. I felt (or rationalized) that if I took the idea of equality seriously, it seemed fair for Bill to have a year off

after all that he had gone through. My mother was proud, Bill's parents were horrified, and I was terrified. But I had serious reservations about living in Texas and had no idea how we would manage; even more troubling, I worried as to whether I was qualified for the position. I was also concerned about what this transition would mean for David. I felt a sense of panic, and, for one of the few times in my life, I didn't listen to my intuition. I am not sure I felt I had a choice.

Regardless of where we went, it was going to be difficult to pull up roots and leave our intimate circle of friends in New Haven. I remember my dear neighbor Sally Tyler running down the street, crying as our moving van pulled away. While we came back to Lincoln Street many times, enjoying nurturing reunions, we never experienced again the loving security of the extended family that this neighborhood represented. It was a huge loss. Even now, almost forty years later, when I hear my former next-door neighbor Joanne say my name in her special way, I feel so much pleasure. While our moving van traveled to Texas, we flew to Charleston to join Mom and Dad for five days at DeBordieu Beach. Hurricane Dennis roared through South Carolina the day before we were to fly to San Antonio, and Dad somehow determinedly drove us through fallen trees and power lines to catch our plane so we could close on our house. In addition to the pilot's son, we were the only people on the plane that day. We couldn't decide if this was a good omen or bad.

San Antonio is the only place I have lived where I felt completely out of place. We moved from a university town to a sprawling city where our neighbors, while nice, were mainly retired military. I never adjusted to living there. I never got the social cues correct, and my version of femininity had little to do with the stereotypical Texas woman. I was neither the big-haired bleached blonde with heavy makeup, tight jeans, and cowboy boots nor the amazingly smart and tough woman rancher. And, for someone who wore her heart on her sleeve, Texas was not a great fit. I was appalled at the brutal way

animals could be treated and the apparent lack of empathy even for pets. It was an aggressively, almost clichéd macho society, and most pickup trucks had gun racks in the back, which unnerved me; spiteful drivers cut me off on more than one occasion because I wasn't exceeding the speed limit. The museum's six-foot-five building manager wore a cowboy hat and boots and had an aggressive, ridiculous, old cowboy movie swagger, which should have been humorous but some part of me found it threatening. Shortly after we arrived, we were taken to a country dance hall to enjoy a few drinks and learn the Texas Two-Step (which I failed miserably at). The sign before entering said, "Please Check Your Guns Before Entering"—it wasn't meant as a joke. I wish I could have been more carefree about this, but this was not a brief holiday. I was living here, and I felt ill.

In addition to cultural disparities, the physical environment with live oak trees and subtropical planting was different from any I'd known. I missed the changing seasons so imprinted on my internal rhythms and lived in fear of encountering the omnipresent Texas-size insects and snakes. The first night in our house, waiting for our furniture, we slept in sleeping bags and woke screaming as we watched huge roaches crawling all over the walls and ceilings, some even flying. We never fully eradicated them. The climate and traffic in San Antonio did little to assuage the fact that I had a demanding job and conspired to make life more difficult: the evening commute home was stressful because traffic patterns changed from eighty to forty-five miles per hour with no warning, making it impossible to decompress. Totally stressed, I would open the door and see two sweet faces, whom I loved dearly, happy to see me and wanting to know what's for dinner. The yard provided no respite for a relaxing glass of wine. For many months, the temperature could hover between 95 and 110 degrees with stifling humidity, and on more than one occasion a roach dropped from a live oak tree into my wine glass.

The house we purchased didn't feel much different than renting because it had neither New England charm nor southern style.

Bill liked to say it was a period house but the wrong period. It was a pink, Eisenhower era, ranch-style dwelling, a 1950s "treasure" locked in a time warp. With the help of our New Haven friends John Clarke and Michael Larvey, who had moved to Austin, we got rid of the green carpets and green cabinets and green flock wallpaper and quickly transformed the living room and family room into livable space with parquet floors and Mexican Saltillo tile. Michael was six foot five and could paint the room without a ladder. He quickly dismissed my messy attempts at help and in his inimitable and loving style said, "Honey, just go in the kitchen and cook us some of your wonderful meals."

Going back to work full-time was hard, especially in a new city without a support system of friends. David was only seven. Up until this point, I had worked part-time with a flexible schedule, but now I missed him terribly. I missed not being physically present, not picking him up at school, feeding him snacks when he got home, watching him play with his friends. I missed not knowing his teachers and some of the other parents. It was a poignant loss. David went from the cosseted environment of a private New Haven school to a public school, where his classrooms were repurposed Air Force barracks and the outdoor water fountains resembled cow-watering troughs. We moved him to an excellent private school, Saint Mary's Hall, the next year, reminded that Texas was near the bottom of all the states in terms of the amount of money spent on education. Fortunately, Bill was able to bring in some salary and stay closely connected to academia. He taught two semesters at the University of Texas in Austin and for one year received a prestigious Samuel S. Guggenheim Fellowship, an important professional honor that provided a stipend for a year of research. He also finished his catalogue for the Tate Gallery exhibition, *James Barry: The Artist as Hero.*

I made it harder for myself because I wanted to continue to meet traditional "housewife" expectations—cooking dinner every night, food shopping, laundry, helping with homework. I also continued to assume the "emotional labor" for the family, as most

women still do. For me to ask Bill to take on more of the stay-at-home dad's role, so accepted today, was pretty much unheard of in the early 1980s. I don't want to suggest I was a trailblazer, but it was difficult; I did not have a blueprint to follow nor did I know any women with young children working full-time. To the degree I succeeded, it is because of the flexible schedule of my husband, who was a caring father, and the periodic help of my mother, whom I needed desperately, after-school childcare options being nonexistent.

The truth is I struggled with the role of being the primary breadwinner. Societally in the early 1980s, we were just on the cusp of a new world of changing roles. When we made the decision to move for my job, I thought I was liberated enough to give Bill a year off to regroup after Yale, but I soon discovered I harbored traditional ideas that men were supposed to be the providers. Somewhere deep in my psyche being the primary breadwinner ran dramatically against a need to be taken care of.

What I didn't fully realize was that I and others of my generation were at the forefront of a major societal shift, in terms of traditionally defined male and female roles, a shift that was to take decades to achieve. An *Atlantic Monthly* article, "Women in the Work Force," from September of 1986 reported that in 1984 less than 29 percent of married women worked full-time. Additionally, while more women had entered the workforce over the past decade, most consistently rated their employment as less important than that of men. More importantly, the article noted that masculine and feminine roles, around which most Americans had oriented their lives and expectations, were changing at a much slower pace.

As chief curator, I supervised a staff of four and was immersed in the world of art museums beyond academia. It was a young museum, and we all had a steep learning curve, especially since there were competing ideas among board members as to what type of museum it should become. I installed and organized public programming for several loan exhibitions, reinstalled the permanent collection, mentored staff about excellence and scholarship, and

professionally learned an enormous amount. Increasingly aware of the sensitivity of my eye, I finally convinced the museum's excellent exhibition designer that installation was not just juxtaposing works to balance a wall but rather making visual connections that the visitor can discover on their own.

My workload was heavy, but somehow I mustered the discipline to organize two well-received exhibitions with accompanying scholarly catalogues, one of which, *Benjamin West and Revealed Religion,* inspired by a work in the museum's collection, received national reviews. Because of the scholarly nature of its content, some staff and board members were skeptical about how it would be received; happily, it attracted a good, if unexpected audience, including busloads of church groups as far away as fifty miles. Despite these successes, I continued to remain ambivalent about, even wary of the confident professional I was slowly becoming, and the independence and strength she could represent.

One of the more interesting learning experiences in San Antonio was the result of the generosity of a collector, Walter Brown. A large, brusque man, Walter owned a magnificent collection of delicate Chinese porcelain, mainly of the Ming period, which was considered one of the finest in private hands outside China, a portion of which eventually was gifted to the museum. He sent me, the museum director, Keven Consey, who had hired me, and the executive director of the San Antonio Museum Association, as well as our spouses, to Europe for two weeks to look at Chinese and Japanese ceramics in private collections and museums in London, Amsterdam, and Paris. The personal dynamics among the six of us were disastrous, but the learning experience was extraordinary. Not only did it forge my lifelong appreciation for Far East Asian ceramics, it trained my eye to discern subtle nuances and variations in shapes and glaze techniques between regions and among kilns. I came to appreciate the extraordinary complexity of this art form as it evolved over several dynasties. Decades later it would inform my work as a potter.

Notwithstanding our discomfort and unease in Texas, we did respond to the Spanish and Mexican influence and Latino charm so evident in parts of the city, and to the wonderful Tex-Mex food. The eighteenth-century Spanish missions, so tied to San Antonio's history, were evocative and beautiful, and I became interested in Mexican folk art. Through a colleague I was able to buy several unusual pieces directly from Oaxaca, including a remarkable burnished clay black Madonna and a colorful pottery scene of the Devil giving birth to the Christ Child. We were also drawn to the Hill Country north of San Antonio, with its stark landscapes and canyons and rocky outcrops, such as the slabs of limestone at Pedernales Falls. As a family we took trips to look for fossils, reminders of the ancient seas that once covered the area. We made a few good friends, and I regret not staying in touch with them longer.

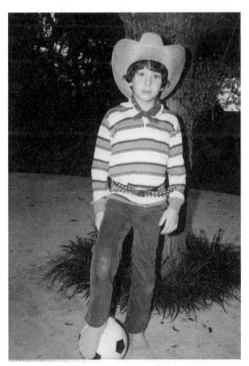

David, our Texas cowboy, 1983

After two years, Kevin, the director, left, and I was caught in a power struggle that involved the larger umbrella organization. I had no buffer or authority, forced to report to the executive director. This was one of the very few times I deeply felt the impact of sexism in the workplace and the Machiavellian manipulations of a condescending superior. To be trapped in this position was both demoralizing and soul-wrenching, and I experienced my first and only searing, dark-room migraine attack. Finally, one day, almost three years after we arrived, I looked out the window and saw our cat, Debbie, in the yard with a large snake in her mouth, holding it right in the middle with both ends moving. I screamed to my husband, "That's it. We are leaving!" Should we be in any doubt about the decision, as we put our house on the market, San Antonio was attacked by a scourge of armyworms. When we put up the "For Sale" sign, our pink house was covered in what I can best describe as a slithering brown latticework.

I am a risk-taker but not an impulsive one, and I am willing to push boundaries. Quitting my position without either one of us having a job was a radical move and an enormous risk, but I had reached my breaking point. I just couldn't stay any longer. It was shriveling my soul, and the stress was unbearable. There is no way David did not absorb the simmering tension and anguish of this period, and I deeply regret that. Bill and I understood the risks but also knew, unequivocally, that we didn't want to stay in Texas. If one of us couldn't find a position before the school year began, our backup plan was to move in with his parents in Atlanta. We contacted friends and colleagues and professors we knew who helped open doors. Soon, we had choices.

Together, Bill and I were offered the joint directorship of the Allen Memorial Art Museum at Oberlin College, where Bill would also have a teaching position. During our second visit to Oberlin, I had my first brief panic attack. We were standing in our hotel room and my heart started to race; for a moment I had trouble breathing. I knew I couldn't do this. I didn't think our marriage would survive

sharing a position, and if we had learned anything in San Antonio it was that where we lived was more important than what we did. Oberlin was such a very small town, and it felt claustrophobic. To the president's amazement, we declined, and instead I accepted a position as assistant director of the Museum Program at the National Endowment for the Arts in Washington, DC. This was a new beginning, and I slowly began to grow and change as a woman.

12. Changing as a Woman

Our decision to move to Washington, DC, was made under enormous pressure and with great anguish. It was probably the most important decision Bill and I ever made together, and it came at a pivotal point in our lives. Bill is an exceptional scholar and had just received acclaim for his Tate Gallery exhibition, bolstering our confidence that he would find a suitable tenure position. We were thrilled to be living in Washington, a city with a domestic scale, one which provided intellectual stimuli, great museums, and wooded parks with trees I recognized. It was just before we settled in Washington that we took that trip to upstate New York, following the Hudson River to its source. The beauty of the landscape where I grew up and my love of the Hudson River all came back to me. Being back East felt like I was moored and home again.

We quickly settled into our new life. David was accepted at Sidwell Friends School; we looked to purchase a house but, with interest rates at 12 percent and limited time to search, rented a home in a convenient neighborhood near Friendship Heights. Bill soon had a contract to catalogue the Folger Shakespeare Library's collection of paintings, a project that was eventually published by Yale University Press, and he began to look for teaching positions. David remembers these years clearly, reminding me, "You were the primary

breadwinner, sacrificing a lot to make it all work and have a roof over our heads, and then you still managed to cook and do everything for Dad and me." He seemed surprised that I had felt guilty for not spending more time with him, and he has no sense that he missed out by not having me around more. What he is certain about is that being an occasional latchkey kid in high school made him more street savvy and independent.

One of the extraordinary things that happened in our move to Washington was how Bill and I carved out different career paths within the same field. In accepting the position of assistant director of the Museum Program at the National Endowment of the Arts, I moved away from scholarship and being an art museum curator into the very public world of a senior arts administrator. Opportunity led us down different career paths within the same profession, and I have no question this was for the better for each of us and for our marriage. In the years ahead, we never competed and remained closely connected to each other's work as careful readers and editors, and as companions on our many trips. Bill's position and his colleagues kept me connected to the academic life, and this was vital to me.

After a year in Washington, Bill was appointed associate professor at Duke University and began two years of commuting, something I would not recommend. Our family managed apart but did not thrive, and I continued to feel conflicted about working full-time and not being as present a parent as I wished. A couple of days a week, I would skip lunch and hop in a cab to pick David up after school and bring him back to the office. Bill would come back from Durham, stressed from traveling and being alone, and, once together, we both wanted a respite from responsibilities. The transient nature and uncertainty of our lives weighed heavily on us.

For me, being assistant director of the Museum Program at the National Endowment from 1984 to 1991 was a new kind of position. It was thrilling to be close to the center of art discourse and catapulted to the national stage. I quickly assessed the constraints of working for a government bureaucracy and embraced the

opportunity to gain a broad overview by traveling to museums across the country to ascertain how the Endowment, through its granting programs, could advance the field. These visits were an extraordinary privilege and opportunity, and I gained a broad understanding of American art museums in their civic context. Some of these site visits could be thrilling in unexpected ways, like touring storerooms obviously in need of upgrades at the Indian Arts Research Center in Santa Fe, where amazing pieces of Native American pottery rested like common objects on shelves waiting to be researched and conserved, a reminder of the critical role of stewardship. I had the opportunity to discuss with curatorial and education staff new approaches to installation and interpretation of the permanent collection as museums explored ways to diversify their audiences and enrich the visitor experience. It was a time of experimentation: paintings and decorative arts from a particular period were exhibited together in the same galleries; staff pondered whether to present the contribution of African American artists with their contemporaries or emphasize their contribution by creating separate galleries; and various disciplines hotly debated the degree to which music and anthropological materials, the cultural context, should inform displays of African and Native American art. Museums also experimented with open storage, where entire collections could be shown, and with how to employ technology to make collection information more accessible.

It was a position of significant responsibilities; I helped assemble peer panels and co-chaired meetings that occurred throughout the year to review applications and recommend grants for special exhibitions, collection management and presentation, and educational programs. Reading applications from hundreds of institutions provided invaluable insight into the state of the museum field and some of the most important projects planned for the near future. In leading panels, I encouraged lively debate and offered information in terms of my overview, as needed, but was scrupulous in not trying to sway decisions.

I developed a reputation for fairness and innovative thinking and became a strong advocate for museum needs within the Endowment as the different arts programs competed for limited funds. I got to know some of the best museum minds in the country as they debated critically important museum and art history issues and developed a broad base of contacts, which would serve me well in the future. I came to realize I had the capacity for big-picture thinking and the ability to synthesize a lot of disparate information. I gradually assumed a leadership role and had a national profile, representing the NEA with authority and deep field knowledge at important regional and national meetings. I was making a difference, and this was important to me.

The big question dangling above us like the sword of Damocles was whether Bill would receive tenure at Duke University. We had no idea how or when this would be decided. In 1987, we had been married almost seventeen years; I was forty-six years old, and I desperately wanted a home that was ours, one that, unlike our home in San Antonio, we could sink our hearts into. Around this time, Anna Quindlen wrote a prescient column: "Life in the 30s—Even a job and baby cannot still the nesting instinct" (*New York Times*, March 4, 1987). I still have this article; it put into words my intense longing not only for my own nest but also for time to feather it, to put together what Quindlen called those "small bits and pieces, woven together, arranged correctly until you are comfortable sitting amid them." I wanted this so much, to wallow in domesticity in my own house, to spend just a little more time as a homemaker and a little more time in the moment, baking bread and making cakes and choosing wall colors. I needed to nest, and not having my own home tapped into my deepest neediness, becoming a magnet for my disappointments. Not having a home of our own became a symbol to me of instability; it was my emotional trigger point, a time bomb ticking, the opposite of weaving a nest, of weaving our lives closer together. It's not that Bill didn't want a house; rather, I needed it in a much more profound way, and having a home where we could settle repeatedly eluded us.

During these uncertain years I sought professional help again to unravel my feelings and needs, hoping to find a way to cope better with stress and soothe my longing. An insightful and caring psychiatrist, Jim Egan, helped me understand that I need not frame my conflicting selves as a dichotomy; that my caring and empathetic side, my good listening skills and my desire to do everything to the best of my ability—what I considered my personal strengths—could also be among my professional strengths. I was finally able to internalize what was so obvious: that I could be the loving and sensitive and empathetic person who relished domestic pleasures and STILL embrace my leadership skills, already evident at the NEA, and let my ambitious side blossom. I need not worry about being too assertive (read: masculine). Most importantly, I realized that I was more in charge of my own happiness and decisions than I thought.

This was some thirty years ago. I had internalized what today is described as "gender judo," marrying warmth (e.g., the feminine) with dominance (e.g., the masculine), a concept that still has currency. The *New York Times* hosted a conference in 2019 on the progress of women in the workplace, devoting a whole section to the conference. I was surprised to read its lead article, "Gentle, Harsh, Remote, Accessible—What's a Woman to Be?" (June 17, 2019). The article concluded what I had learned so many years earlier: "maybe all those things at once." Was I that ahead of the times? The subtitle could have as easily been "What's a Man to Be?"

Becoming increasingly clear to the three of us was that Washington, with its museums and parks and energy, was an ideal place for us to live. We had proximity to New York and enjoyed our excursions into the Blue Ridge Mountains and vacations on the Outer Banks, thrilled to be near the Atlantic Ocean again. David enjoyed Washington, his school, and his new friends. David and I were loath to move to a small college town like Durham, North Carolina, but a commuting marriage would be difficult for the family to sustain for very long. Thankfully, we never had to face what would have been an excruciating debate as to whether we were going to move

to Durham, because in the spring of 1987 Bill was offered a tenured position in the Department of Art History and Archaeology at the University of Maryland, College Park, where our Institute of Fine Arts friend, June Hargrove, was also a professor. We were ecstatic, over the moon, overjoyed! Finally, the uncertainty that had so permeated our lives was over. Washington would be our home. It is hard to overstate just what a difference this would make for each of us individually and for our life together—a critical balance had returned, and academia was once again at the center of our lives, a connection I deeply valued.

13. Nesting and Leadership

Once Bill was tenured at the University of Maryland, it was time to nest! We weren't looking for the perfect house, but by this point we were beyond a starter home. Most homes available that we could afford were older dwellings, and my brother, a builder of modest development homes in New Jersey, offered to assess them. He rejected the two we seriously considered because they needed too much work, and I was terribly disappointed. Bill and I can't recall why we were so passive in accepting this, but presumably Bobby and my mother were going to help with the down payment. Bill's second open-heart surgery in the summer of 1987, before he began at the University of Maryland, may have factored in as well.

My brother soon decided he wanted to build us a house, an immensely generous offer, but from my perspective not a realistic idea. I did not want all the pressure and decision-making that comes with building a house, nor did I want to delay having a home for the two years such a project would require. I clearly voiced my apprehensions to my mother, including my concern that Bobby, who lived in West Milford, a rural area some twenty-five minutes from Nanuet, might not understand the Washington market. I was also concerned about the practical logistics given he lived so far away. With my mother fully supporting Bobby's desire to build our house despite

my concerns, we felt pressured to acquiesce, and it is difficult to turn down a free house. Still, I feared it would be a nightmare, and I would be losing control over something that was so important to me. Even now I feel immensely guilty for writing this, because my brother was so generous in wanting to do something special for me. But I can also see in hindsight that once again some longstanding dynamic was playing itself out, echoing the argument that I was not smart enough for Goucher or able to execute my mother's birthday party—that, somehow, I was not capable of finding a home myself. To his enormous credit, Bobby bought an excellent piece of land adjacent to Kenwood, a tony Maryland neighborhood just outside the District. His plan was to subdivide the parcel into three lots and pay for our house with the profit he would make off the two additional houses he would build and sell.

Then my brother and his wife unexpectedly separated, headed toward divorce, and he completely fell apart. Following his marriage in 1972, Bobby had come into his own, especially as a loving and supportive father who was very much involved in his children's lives, from vacations to sports. He had a strong sense of family, remaining close to my mother, and took good care of his wife's parents. Bobby was a deeply good, honest person, a loyal friend, and a sweet and generous individual who initially struggled to find his place in the world, eventually becoming a successful builder.

After Bobby and his wife separated, his children, Colleen and Tommy, stayed with their father, who was devastated much as he had been when Dad died. Then on February 2, 1989, he suffered a massive heart attack and died instantly. He was found by his young son, who in the middle of the night had gone to him to be comforted after a nightmare. The breakdown of my brother's marriage was an enormous shock coming completely out of nowhere; I sometimes think he literally died from a broken heart.

He was buried two days later (the children placing some of their favorite things into his coffin) next to my father, and I stayed with my mother for a week as we tried to console one another. The

evening I returned home, my fifteen-year-old son comforted me as I sat still in shock on the living room sofa. I was so grateful. But, in a flashback, I remembered that sweet toddler reading to me on a couch so many years earlier; I tearfully thanked him, telling him to go back and be a teenager again. I would be okay. Bobby's two children were in terrible shape for a very long time. Tommy would fly down to visit us every few weekends for almost a year, carrying a pathetic, small, battery-operated fan, which helped him to not hyperventilate from his terror of flying. Colleen initially stayed to herself, but she and I over the years have become close and nurture a special bond I deeply value. My mother was completely devastated, and my reaction, too, was dramatic. Losing a sibling out of the normal cycle of life threw me completely off-kilter. Now I was totally on my own, and I was my mother's caretaker. It was like a tsunami coming out of nowhere, covering everything and then receding, leaving all who remained in chaos. I felt overwhelmed with responsibilities to my family at the same time that the Arts Endowment was beginning to come under a long siege of attack. I lost ten pounds, barely tipping the scale at one hundred pounds, and struggled to keep from going underwater.

Five months after my brother died, the house we were renting was up for sale. Building a home was out of the question even though Paul Bailey, a New Haven friend and talented architect, had schematics for a wonderful design and had built a beautiful wood model of the house. But I did want to salvage the intent of my brother's plan to develop and sell the land, which could make enough money for a down payment on a house. So began the tricky dance of purchasing the property for market value from Bobby's estate and purchasing a home—and trying not to link these transactions. Working with my lawyer, our goal was to finance the purchase of the house through a bank bridge loan, with the property as collateral. As we sat in his office, the bank executive requested the house as collateral as well. I refused, not willing to let the bank (read: anyone) have this kind of control over me. The next day I got the loan anyway.

I became a part-time developer, working evenings and weekends with an engineer my brother had hired to rezone and subdivide the land and petition to put in water, sewers, and build a private road. The property was listed for sale, and I was exposed to the sleazy world of developers. At one point I was even sued for a million dollars by a buyer who defaulted on his contract. The suit was dropped, but not before I endured the painful experience of a deposition. That day was like a perfect storm: my grief, my anger, my helplessness and sense of inadequacy totally entangled in family dynamics I thought I had left behind thirty years prior. My son and Bill watched in amazement as I absolutely fell apart after the deposition, returning home to cry on my bed, curled in the fetal position. It was the most fragile David had ever seen me.

It was during this period of craziness and loss that my therapist, Dr. Egan, made a comment that somehow stuck with me. I came into his office terribly depressed one day and told him my prescription for Prozac wasn't working. He looked at me and said, "Okay, let's look at what has been going on: in the past two years, you have lost your brother and two aunts and an uncle and a young cat you deeply loved like a child. You are now solely responsible for your mother and are worried about your niece and nephew, your job is going down the tubes, and you are trying to develop your brother's property. If this doesn't work, a potential financial catastrophe is looming. And you tell me Prozac isn't working! Through all this you are handling the stress remarkably well. You have reality problems, and I am not very effective with reality problems. You are the only patient I have who makes me anxious." I laughed. It was so to the point.

Bill and I purchased a new, beautiful Victorian-style house with a spacious modern interior, borrowing money from my mother that was immediately returned after I sold the land. We moved in a week before Thanksgiving in 1989. I was deliriously happy at the closing: we were finally grown up and stable after a staggeringly stressful and totally bizarre experience. Five days later, without missing a beat, I

made Thanksgiving dinner for Bill and David, my mother, and my niece and nephew in our new home.

Embracing my nesting instinct, I found incredible joy in the physical comfort and pleasure of my home, cooking for and caring for my family, tending to my vegetables in my first garden. I cherished that house every day I was in it, and we loved it as a family. I was finally able to fill a home with our British prints and drawings and the china and ceramics we had collected from our travels. With money my beloved aunt Esse had left me when she died, I purchased a few pieces of contemporary furniture that still fill me with pleasure, reminders of her. Over the years we assembled an interesting assortment of natural objects, and I had a three-tiered display table designed with the help of our friend Athena Tacha to display them. Shells, coral, rocks, and dried mushrooms share space with a fox skull, wasp and birds' nests, and unique objects: a small tree branch hammered with woodpecker holes, which looks like an otherworldly flute which we had collected on our walks in Rock Creek Park and on our travels.

My happiness in having a home that we could make ours surpassed everything I had imagined, and the glow never wore off. And most importantly, the family unit got stronger and grew to include three cats: Calypso, Asher, and Rocky. Cats are crazy important to me, and I can't think of this home without seeing them everywhere, making me insanely happy even though the beautiful Calypso scratched and snapped at everyone else. I sometimes ache for Rocky to sleep on my chest, which he did almost every night for eighteen years.

When I turn my mind to the years of my family's life in our Washington house, I see everything I longed for. I see layer upon layer of Thanksgiving dinners with numerous vegetable side dishes, a twenty-two-plus-pound turkey with a chestnut-sausage stuffing regardless of how many people came, and pumpkin chiffon and pecan pies. We had the same friends each year including Pearl and Seymour, often adding new faces as well. The table was set with my

mother's beautifully embroidered tablecloths, casually arranged flowers, our china and silver, and a few simple, eighteenth-century family serving pieces—always elegant and timeless. Christmas was defined by sumptuous dinners and family gathered by the fireplace to open presents while the cats played with ribbons and wrappings. Mother, Mom and Dad, and Paul and Jane joined us the first few years; on Christmas Eve I would serve a three-course meal with prime rib roast and special wines. Christmas Day was almost always celebrated with a stuffed goose, lots of accompaniments, homemade yeast rolls, and sometimes the meal would end with a beautiful homemade Bûche de Noël with meringue mushrooms and chocolate bark.

I also see my son and his friends taking over the lower level of the house, which had its own entrance; this was the studio for their band, with David playing drums. The band was amazingly good! This downstairs area later morphed into my high-powered office. Bill and I were welcoming hosts, and I see our spacious kitchen at the front of the house often filled with friends, drinking good wine, as I finished cooking. Photographs capture my happiness: a kitchen apron protecting my dressy attire, guests by my side, with my wraparound smile and wine glasses in both hands. Ours was a perfect home for celebrations, which included a going-away party for my dear friend Art Warren when he left the Arts Endowment; my son's engagement party, with the garden filled with flowers; and a sit-down dinner for twenty celebrating Pearl and Seymour's fiftieth-wedding anniversary. We hosted the Art History Department's annual beginning-of-the-year party for years, and our house was a welcoming home to graduate students. I see with emotion my mother's festive ninetieth birthday in 2001, when her grandchildren and nieces and nephews and some of their children gathered to honor her. In our spacious living room, we watched together a slide show of her life. Although she was already suffering from severe dementia, she was happily the center of attention. I still have the black and white polka dot dress I bought for her, somehow not being able to let go of it.

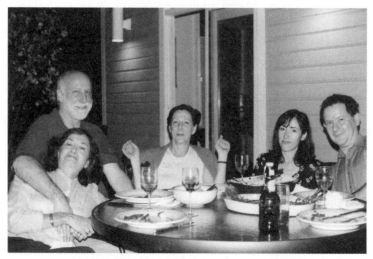

With Bill and art historian friends, June Hargrove,
Suzanne May, and Alex Kidson, Washington, DC

My niece and nephew Colleen Saar and Tommy Dee, 2001

Something else had also changed in owning a wonderful home. I finally came to peace with this being something I had to do for myself. My take-charge self, the feisty and strong me, had made it happen—and it was okay. I didn't resent that I had done this, and I wasn't conflicted. I was finally liberated. I had unleashed my leadership side, and I could take care of myself. I acted on my deepest desires and had given this gift to myself and my family, and it was all fine. The family unit wasn't split open by my desire, as it had been with my parents so many years ago; it was only stronger. Although I did not make the connection at the time, I can see now that spirited teenage girl I once was, the girl who loved a young man, and all the strength she represented was finally released. I took financial risks and fully embraced my desires, and nothing bad happened. I had let the stronger, assertive side of myself unequivocally prevail, and I was no longer afraid of the consequences. I had broken free, and everything was not only okay, it was great. Only now, writing this memoir, can I understand how momentous this was. It would become even more important in a few years.

14. Nurturing the Soul

Walking for me is like a form of meditation and mindfulness. It can totally slow me down mentally, and I can go off into deep interior spaces. One of the joys of our new home was we lived near Rock Creek Park, where Bill and I would frequently hike together along miles of wooded paths. We often walked silently, looking at leaves and forest moss and mushrooms caught in sunrays, listening for birds or deer, chipmunks dashing across the path. Sometimes we walked on the Billy Goat Trail, along the Potomac River near Great Falls, and on the C & O Canal. I cherished these times together and opportunities to walk in isolated places I couldn't do on my own. We also took weekend excursions to the Blue Ridge Mountains, enjoying the spectacular views and walks on the Appalachian Trail as well as in Western Maryland, where we discovered amazing places like Cranesville Swamp, a boreal peat bog formed some fifteen thousand years ago during the last ice age, with its surreal vegetation and total isolation.

Travel is one of the great pleasures and constants in my life, and the sensorial memory of trips can resonate over a long period of time whether focused on the outdoors or art-related itineraries. I often think Bill and I are the best of ourselves when we travel. Once our lives in Washington became financially stable, we took longer trips

to Canada, Yellowstone and the Grand Tetons, Belize (including an excursion to the remarkable Mayan city of Tikal in Guatemala), and Hawaii, one of my favorite places with its pounding waves and varied landscape, especially Kauai, where we hiked spectacular trails and glimpsed a rare patch of sea and sky near Mount Waialeale at one of the wettest spots on earth. I would become a different person on these vacations: the hardworking assistant director, and later the driven consultant, were left behind. I could totally relax and embrace my more indulgent and adventurous self.

These trips focused on the natural world were essential infusions, reviving my spontaneity and sense of awe. For my sixtieth birthday we went to New Zealand. I still recall the sense of wonder we experienced walking out of our isolated cottage on the north shore of the South Island to be confronted with the amazing night sky of the Southern Hemisphere for the first time. It was a cloudless evening with the Milky Way vividly splayed in bands across the sky. There was no ambient light, only endless crystal clear stars and constellations we had never seen before. I felt again the awe I did as a child looking at the heavens with my father. Later, driving from the Franz Josef Glaciers to Queenstown, we pulled over to gaze at what seemed like an endless river snaking its way through valleys. It was the most remarkable color I have ever seen—a silver-blue with a touch of turquoise glowing in the brilliant clarity of Southern Hemisphere light. On a trip to Costa Rica, we were enveloped in the wet mist of a cloud forest, with lush vines, huge leaves, and moss and drooping flowers everywhere, an immersion occasionally broken by daylight and the sighting of a Quetzal or a deadly yellow pit viper curled asleep in a tree. I took photographs of the mist and enormous leaves, but the images in my mind are more vivid.

From our early days in London, travel has also been about looking at art. I still become excited contemplating a visit to an important museum for the first time, not only about seeing the art but also about experiencing the architecture and what it conveys about the history and identity of an institution. Bill and I believe

art is profoundly important and it is a powerful bond we share, a bond nourished in England and one that only deepened over the years. Art has the power to move me deeply, to make me reflect on who I am as a human being. It can provoke profound musings about empathy and creativity, about the human condition and the need to find meaning.

After I began work at the Arts Endowment and drifted away from scholarship and the sense of identity that came with it, looking at art became a way of reconnecting with the more spiritual and creative side of myself, and I began to approach art in a more open and intuitive way. For an art historian, looking at art is a multi-layered, complicated process, where you balance knowledge with the initial, more visceral response. After all these years, I am certain that the history imbedded in a work of art and the art historical knowledge we bring to it can add richly to our experience. On the other hand, sometimes this knowledge can mute the more immediate and visceral response. I think about my love of opera and how sometimes it can transport me, filling me with emotion because I truly don't understand how it is composed or how notes work, only that it touches me in profound ways.

I like to contemplate how people look at art, how the experience can be so different for each of us, and how works can take on new meaning as we see them over time. Bill brings a remarkable knowledge of history and literature and the Old and New Testaments to how he approaches art. Drawn to the intellectual concept, he can read a painting with a profound iconographic understanding, finding enormous pleasure in deciphering meaning. For me, especially after I left scholarship, something else is also at play—the intentionality in an artist's choices as he/she engages in the deeply personal act of making art. Looking closely at how a work is created in a formal sense allows me to engage more deeply with the artist. I try to plumb a work of art and discern the more personal struggle, to intuit empathetically what is beneath the surface. This more visceral, emotive response allows for unexpected

associations and the ability to make visual connections between artists and across time.

I am also interested in how unpredictable looking at art can be, how much has to do with knowledge and the physical context where it is seen, but also with where our psyche and state of receptivity are on a given day. It is not something you can force, and looking well can be an intense experience. Sometimes nothing comes through, and my eyes just glaze over, or I just focus on a few objects. Other times, I see with revelatory clarity, which can be exhilarating. On occasion these can be what I call aha moments, where something I have seen or knew of suddenly comes into brilliant focus or emotionally resonates in a new way. I have always admired Goya, but on a visit to the National Gallery of Ireland in Dublin, I came across his extraordinary *Portrait of Doña Antonia Zárate* (1805) (see color photo insert). Everything else in the room faded away. I had an almost visceral appreciation of what "making" art was all about. I looked at every inch of the painting and marveled at the bravura of his execution, the sensual juxtaposition of colors, the exquisite detail of the mantilla, and the sitter's penetrating gaze, but in the end, what excited me most was the aesthetic experience, this luscious human endeavor.

Another such experience was in Florence. I escaped from the crowds and entered the small church of Santa Felicita, where, to the right of the entry, above the altar in Brunelleschi's Capponi Chapel, was Jacopo Pontormo's *Deposition from the Cross* (1526–28) (see color photo insert). It is one of the most enigmatic, strange, and beautiful paintings I have ever seen. I was absolutely stunned by the intense, almost strident, pastel colors of the drapery, which in places clung so tightly to the grieving figures as to appear translucent. Several of the figures holding the body of the dead Christ are impossibly balanced on their toes, adding to the instability and hallucinatory quality of the entire composition. The daring of the artist and the brilliant virtuosity of this Mannerist masterpiece has haunted me ever since. Despite further reading, I am not certain I will ever understand it.

Another aha moment was when Bill and I were standing on the promontory that was once the ancient city of Pergamum, gazing out at the immense vista before us. Although the great Altar of Pergamum is in Berlin, we walked through partially reconstructed ruins like the Temple of Trajan and were immersed in the rubble and ruins of this great city. There were no guards or fences or entry fees, just the reminders of former glory and the passage of time, more moving in a different way from the much more intact city of Ephesus. No photograph or amount of reading could evoke the power of that moment.

It can take patience and openness to have a meaningful encounter with a work, however famous it may be, something most museumgoers miss since visitor surveys indicate the average time a viewer spends before a work is less than thirty seconds. Recently I saw Piero della Francesca's *Resurrection,* (see color photo insert) an undisputed masterpiece of Renaissance art, housed in a former civic space in the artist's hometown of Sansepolcro. I looked at the painting and started to move on but was drawn back, reentering the space. The work is mounted high, so that when you walk into the room you are immediately struck by the frontality of the monumental figure of Christ rising from the sepulcher, almost like some motionless archaic Greek kouroi standing above you. In front of Christ are sleeping soldiers in richly colored contemporary Renaissance dress, impossibly compressed into the limited foreground space. Christ stares out into a space beyond the viewer, another reality we can't see. The painting's supernatural stillness is unsettling. I looked intently, and while I did not have the knee-buckling experience some have had before this painting—Aldous Huxley described it as "the greatest picture in the world"—it did communicate some higher meaning. It reached me spiritually and remains vivid in my mind.

What I am certain of is that this kind of deeper understanding can only happen when you are before a work of art or physically present at an architectural or archaeological site. It wasn't until I visited the beautiful Villa Barbaro, near Maser in the Veneto, that I understood for the first time how a sixteenth-century Palladian

villa functioned in the countryside and what an extraordinary personal expression it could be. The Villa Barbaro was a special kind of retreat for its owners, an intimate personal conceit yet still rooted in its agricultural function. It is notable for its brilliant, witty, and illusionistic frescoes by Paolo Veronese, which include trompe l'oeil contemporary figures of the owners and their families. Marcantonio Barbaro leans out of a partially opened, illusionary door as if to greet the spectator, while his brother, Daniele, in another room, stands on an illusionary balcony near a patrician woman, probably his wife, who looks down into our space.

In Venice I sat with my friend Art Warren looking at Giovanni Bellini's *Frari Triptych* in the Pesaro Chapel in Santa Maria Gloriosa dei Frari, a painting I was familiar with from reproductions. We sat for some time, quietly sharing the experience of viewing this masterpiece. I began to realize something else was also happening; I was "seeing" this painting in a way that transcended knowledge and felt so authentic and spiritual. Sitting there, I began to absorb what the painting was intended to do for those before it in devotional prayer over four centuries ago. Art and I were able to share an unexpected and moving spiritual experience together. This was so different than seeing a triptych in a museum. I learned later it was intended for this chapel, that Bellini had also designed its wooden frame, and that the flanking saints were the namesakes of the Pesaro brothers, who commissioned it to honor their mother buried there.

My extensive work with museum issues has made me acutely aware of the visitor experience. Even now, when I enter a museum, I am always assessing what the visitor sees and feels: is it welcoming, is the wayfinding clear, does the first-time visitor know where to begin? Likewise, without even thinking about it, I assess lighting, wall color, labelling, and if the installation is sympathetic to the objects on display. While in the Uffizi Gallery, I found it difficult to engage with the three large panel paintings of the Madonna enthroned by the early fourteenth-century artists Duccio, Giotto, and Cimabue. These are iconic images for any art history student. Admittedly, with

crowds of people wandering around, these were not ideal viewing conditions, but it bothered me greatly that I had trouble looking at them in any kind of meaningful way. It slowly dawned on me a few days later that perhaps the installation had partially affected my response. These three paintings were juxtaposed like an art history lesson in a large gallery with bright, modern installation. Completely out of context, they challenged each other; there was no hint of the spiritual environment for which they were intended.

I had a very different experience during a trip to the Baltic when we spent a day at the State Hermitage Museum in St. Petersburg. Part of the modern collection had been recently reinstalled in an adjacent building, and, thanks to the Russian guide/monitor we hired for a day, we were able to see the Hermitage's notable Matisse collection in nearly empty galleries yet to be discovered by the public. I was enveloped by some of Matisse's most important paintings from 1907–1915, commissioned and purchased by Sergei Shchukin, the Russian textile merchant, for his Moscow home, Trubetskoy Palace. While I responded to the artist's extraordinary use of color and felt the frisson of pleasure I so often do before his work, I was seeing differently that day. Taken aback by the scale and boldness of the paintings, I stood there, following the rhythm of execution in work after work, trying to grasp the confidence and mind-bending imaginative thinking that created them. The juxtaposition of colors and ragged brushstrokes in his paintings seeming more vivid and textural than I remembered; the rawness and energy and the scraping and incising of surfaces made me constantly aware of the artist's presence. Looking at *Music* and *Dance* (see color photo insert), both from 1910, it occurred to me that Matisse's distillation of the early twentieth-century's embrace of Primitivism may have been more radical than any of Picasso's images from the same period.

I was rivetted by the intensity in Matisse's use of blue in *The Conversation* (1908–12) (see color photo insert), a self-portrait of the artist and his wife, and by the tension and emotion that filled the space between them. The blue almost becomes the focal

point of the painting, underscoring how Matisse could use color in a brilliantly intuitive way, making it emotional and significant. I also mused about the critical role played by patronage: by 1914, Shchukin had purchased, during his trips to Paris, thirty-nine works by Matisse and fifty-one by Picasso, many of which I had seen a few hours earlier. It was a thrilling day.

As I have grown older, I have thought more about empathy and the aesthetic experience, how sometimes looking at a work of art I can have a strong intuitive connection with the artist and the deeply personal act of making art. There is generally something heroic or especially profound in the effort, that communicates a deeper meaning. This connection can be brief, but it is powerful, and later I remember the encounter, my thought processes, and exactly where the work was physically situated. It remains alive in my mind's eye long afterwards. This was my experience when I saw Goya's *The Third of May 1808* (1814) (see color photo insert) at the Prado so many decades ago. At the National Archaeological Museum of Athens, amidst numerous archaic Greek sculptures, I stood mesmerized before a life-size Kouros, a grave marker, for a fallen warrior identified as Kroisos in an inscription on the base. Known as the *Anavysos Kouros* (540–520 BC), I marveled at how the unknown artist conceived the remarkable symmetry and subtle modelling of the warrior's powerful body and how dramatic it would have looked silhouetted against a Mediterranean blue sky. I returned to look at it several times before I left the museum that day.

I have also felt this strong sense of connection with particular works by Jasper Johns, especially his *Seasons* series, which I saw when it was first exhibited at Leo Castelli Gallery in Soho in the 1980s. Similarly, I have stood in contemplation before some of Anselm Kiefer's monumental paintings or a large-scale Joan Mitchell painting from her Paris years, absorbing how, in each instance, the artist so brilliantly intertwined the physicality of the act of making art with his/her probing of deeper issues and emotions.

Drawn as I am to ancient art, I often look for larger connections, the continuity of certain artistic impulses and forms across millennia. I think of the beautifully carved worshipping figures with clasped hands from emerging urban centers like Uruk and Sumer circa 3000 to 2600 BC and the group of Proto-Elamite objects found near Susa in Iran that include the extraordinary *Guennol Lioness* ca. 3100–2900BC (see color photo insert). On loan to the Brooklyn Museum for decades before being sold at Sotheby's to a private collector in 2007 (for the astounding price of $57,200,000), this half-lion, half-human sculpture measures only 3.25 inches, yet its realistically carved, powerfully modelled body projects a monumental presence. With its furrowed brow and rippling energy emanating from the subtlety carved planes of its arms and clenched "fists," it is imbued with humanlike emotion, an extraordinary aesthetic achievement from an ancient culture of which we know very little. I think about these ancient works of art and how they embody the deeply human need to create and to evoke the spiritual dimension. They reflect a quest for meaning that links artistic endeavors across time.

Finally, art has the ability to communicate meaning beyond words. On rare occasions, I have had an overwhelming, ineffable aesthetic experience before a work of art during which I have been completely, instantly overwhelmed—subsumed by what is before me, caught off guard, like when I saw Rothko paintings as a college student. This happened at the Philadelphia Museum of Art; when entering a gallery, I was confronted with Rogier van der Weyden's *Crucifixion Diptych* (see color photo insert). I leaned against the wall; my knees were about to buckle. One never knows when such moments will happen, why this painting with its powerful and simple geometry and timeless poses had this effect.

What I do know is that these moments of vision somehow express some greater truth. When Bill and I went to see Louis Kahn's masterpiece, the Salk Institute, in La Jolla, California, the campus

was closed, but a kind guard let us in. We were alone and it was an oppressively hot day, and then we came upon the site, silhouetted against the blue sky with the beam of water crossing the plaza, leading into infinity. We gasped and stood motionless and then held each other, looking at a vision totally realized in the landscape. Years later, in Seville, I stood in the courtyard at Alhambra, with its long, narrow rectangular pool ablaze in the Spanish sunlight and wondered if this had been Kahn's inspiration. On a trip to Istanbul, we visited the Rüstem Pasha Mosque, also known as the small Blue Mosque, which is a one-room space decorated in sixteenth-century, exquisitely colored Iznik tiles. The light was perfect, and I was overwhelmed. Bill looked at me and said in astonishment, "You are crying." I could barely speak except to say, "Yes, it is so beautiful." These are the rare and profound aesthetic and spiritual experiences that one never forgets. This belief in the capacity of art to deeply move us and thrill us is central to my being.

President, Nancy L. Pressly & Associates

15. Owning a Career and
Making a Difference

When I think of my professional life and personal qualities that contributed to my success, I am most proud of my strong sense of integrity and moral compass and commitment to doing the right thing even if it comes at some personal costs, values nurtured in me by my parents' example and those family dinner conversations during the McCarthy era. Most of us are not faced with having to take a strong stand in this regard, but I was during my last years at the Arts Endowment. I co-chaired the peer panel that reviewed special exhibitions when the Institute of Contemporary Art in Philadelphia submitted its application for *Robert Mapplethorpe: The Perfect Moment,* which became the lightning rod for a congressional attack on the Arts Endowment that began in 1989, just months after my brother died. To this day, I can remember how thoughtfully the panel came to their conclusion that the exhibition would be a serious assessment of an important but controversial artist, undertaken by a highly respected curator and institution.

The controversies that ensued over this grant and others, including one from the Visual Arts Program to the artist Andres Serrano, who created *Piss Christ,* had an enormous impact on art discourse in

the late 1980s and early 1990s and the culture wars that ensued. The Museum Program and the Visual Arts Program were at the center of the controversy, subject to questioning before Congress with respect to budget considerations and how peer panels made their recommendations. During this period the NEA was under enormous pressure to modify its decision-making process and, in some instances, not to bring recommended but potentially controversial projects before the National Council on the Arts for approval. This set off what became searing internal discussions, with some Endowment staff urging expediency and placating congressional members with the hopes of saving congressional funding. More problematic was the fact that a few senior staff who held sharply conservative views were willing to let personal beliefs sway or later overturn peer panel recommendations. The specter of intimidation and censorship began to infiltrate the panel review system and the NEA. A small group of us pushed back and tried to protect the integrity of the panel process. I firmly argued guidelines should not be changed after museums submitted in good faith their applications and urged panels not to be swayed by the cultural wars being played out in the headlines. My position was known and much appreciated in the field.

A few of us occasionally faced personal attack from within, and our situation became more uncomfortable and stressful. Political pressure inside the Endowment and out intensified, eventually focusing not only on what was obscene and appealed to "prurient interest," a subjective definition at best, but also on works of art with overt political overtones. There is no question that freedom of artistic expression was under attack, the slippery slope of censorship in play. We also began to see a form of self-censorship: some museums grew cautious in their submissions, staying away from political content or potentially controversial artists. In some strange twist of history, the Endowment's offices were in the former Old Post Office on Pennsylvania Avenue, now the Trump International Hotel.

With the drama playing out in a highly public forum, the field response was sometimes reactive, even misguided, and disappointing.

The Corcoran Gallery of Art, which no longer exists, cancelled its showing of the Mapplethorpe exhibition just before its scheduled opening, bowing to political pressure while ostensibly doing so to help the Endowment. The Gallery had not shied away from the content of the exhibition when it sent out its opening night invitation, which featured a beautiful and provocative photograph of a white man and a black man, nude from the waist up, embracing. The absurdity of the situation and lack of Endowment leadership reached an apex for me when headlines featured an outcry over the Opera Program's grant to the New York City Opera's production of Arnold Schoenberg's *Moses und Aron,* in which four virgins appeared naked in the opening scene. The opera refused to back down, and the Endowment's public relations office's initial response was something to the effect of "Well, if they are virgins, it shouldn't be a problem." Definitely not one of the NEA's finest moments!

I eventually quit, recognizing I could no longer effect change or tolerate the disillusionment and tensions, and the environment was becoming personally uncomfortable. It was time to move on. A year after my departure, a Museum Program staff member called me to say, "I just want you to know we had a difficult decision to make today, and we looked at each other and said, 'What would Nancy do?'" It was a gratifying compliment, one I have cherished.

My voice did not remain totally quiet. I wrote a letter to the editor of the *New York Times,* published in full on August 28, 1993, which defended a $250,000, multi-project grant to the Museum of Contemporary Art San Diego that looked unflinchingly at difficult border issues in its region. Noting the uproar was over a small aspect of the project involving only $1,250 of federal funds that had to meet a 3 to 1 match, I went on to say:

> The outcry over this project is not just another attack
> on the freedom of expression of artists or the inappro-
> priateness of political commentary in a federally funded
> art project, it represents a subtler form of intimidation.

The Arts Endowment grant was not awarded to the three artists, but rather to one of the most highly respected contemporary art museums in the country.... To attack the museum, or the National Endowment for the Arts for awarding a grant is to support a much more dangerous precedent: that the long arm of the government can extend into the artistic decision-making of individual organizations after the award of a grant....

Bill was supportive of my decision, but what I had hoped would be a graceful departure became, despite going away parties, unexpectedly uncomfortable. This was not what I wanted to happen to my career, and I had no idea what to do. I felt vanquished and scared. I didn't regret my decision, but for weeks I was seriously traumatized and falling apart, suffering in this process, among other things, a severe and painful case of shingles. The full reality was that I was still enmeshed with selling my brother's property and the bank bridge loan; if I didn't find another job within a year, we would lose our house. I sat on the front porch one afternoon with my son, a junior in high school, and told him I was so sorry. I desperately didn't want to lose the house we had waited so long to find, but I had to resign. David put his arm around me. "Mom, it will be okay," he said, "and we had this wonderful house when it mattered most to me in school."

Before I left the Endowment, I applied for and was awarded a prestigious three-month senior fellowship at the Center for Advanced Studies in the Visual Arts to begin a book, for which I had a contract with Oxford University Press, entitled *The Specter of Intimidation: Controversies in the Arts*. The project proposed to take a look at the current conflicts in the context of earlier incidents, in particular the WPA Projects in the 1930s. This fellowship helped ease the transition, but I did not complete the research. The topic was complex, and I wasn't confident I could master it. I also felt too close to events and not comfortable revealing private conversations I had or heard as a government employee. I realized it would take

more time to complete than I could afford because I needed to bring in a salary. I decided to quietly close this chapter of my life.

I turned to friends and colleagues for guidance about next steps. I also began an intense interior dialogue, a challenging and deeply introspective exercise, undertaking an unusual approach, asking myself what I was sure I didn't want to do, rather than thinking about the things I might want to do. This was immensely helpful, and eliminating some obvious possibilities allowed me to think out of the box, which suited me entirely. Two crucial observations emerged: I didn't want to leave the Washington area (especially as Bill had his tenure position at the University of Maryland); we were not going to have a commuting marriage. Second, I didn't want to return to a museum position as a curator or a director, despite the fact I was getting inquiries. On some level, I think I was also shunning traditional trajectories; I no longer wanted to be bound by institutional rules. I was determined to remain flexible and contemplate a different kind of success.

It slowly dawned on me that what I really wanted to do was to run my own business and be my own boss. I was willing to take the risk, to take a road not totally safe because it promised something so much better. I was also aware that funding entities were placing an increasing priority on arts organizations having a current strategic plan. With my unusual overview and in-depth knowledge of the museum field, this was a need I was ideally suited to address. I created a business plan, had classy stationary designed, converted the lower level of our house into a three-room office, and Nancy L. Pressly & Associates came into being. I contacted a few strategic planning firms to see how I could be of assistance, and within weeks one used my name to secure a project at the Nelson-Atkins Museum of Art in Kansas City; my new career was launched. A year later, I was the Nelson-Atkins' sole consultant. I continued to work with them over the next decade on a variety of projects and deeply valued my close relationships with board members, the director, Marc Wilson, and its immensely talented staff.

It took courage to start my own firm: I had new skills to learn, especially as a facilitator. I am visual and retain information by writing it down; as a facilitator, leading meetings, I had to process things aurally and quickly, immediately distilling the conversation on a flip chart. The first two years were scary as I constantly worried if enough new work would come in and whether, in my early fifties, I might be too old to start something new. Would potential clients be looking for someone younger? I recall so vividly my mother offering me the most heartening support, something I had longed for. She told me: "No, you are the right age. Your maturity will be exactly what they will be looking for, and you offer exceptional experience and a national reputation that will be invaluable." To ease my panic, I calculated the minimum I needed to earn to pay the bills (it was less than I had imagined) and learned to forecast income with projects booked a year ahead.

I entered the consulting profession at a time when the museum field was going through turmoil with respect to the cultural wars and drastic cutbacks in funding. My name was well known among art museum directors, and I was one of the few planning consultants who actually understood the complex issues museums face, which gave me critical credibility with board and staff. I embraced the entrepreneurial challenge sometimes with my knees knocking, had some lucky early breaks, and never had to market. I also recognized some of the challenges for a woman consultant, especially as I was building the firm, giving up my artsy and flowery clothes for a more elegant and professional but still feminine demeanor.

It took only a few years to realize I could do this and do it well; I could admit to myself without ambivalence I relished being in charge! I never expected my business to become so successful, and I was exhilarated to get to this point. I also embraced the unexpected rewards of forging close relationships with staff and board members that lasted long after a project was completed. But this was also extremely difficult work—shorthand for logging many extra non-billable hours to achieve the excellence I demanded—but

I was willing to do this. I somehow managed to enter a third career in the world of art and museums, and I felt incredibly fortunate. I soon had a staff of three including two key senior associates, Jennifer Strychasz and Pat Burda, without whom the firm would not have been so successful.

Four years after I opened my business, I was diagnosed with breast cancer and had a lumpectomy, followed by seven weeks of radiation. Some thirty lymph nodes were removed, and fortunately all were clear. I was comforted by the fact I didn't need chemotherapy and my oncologist's confidence that this was an isolated occurrence. Once I got over the initial shock, I was determined not to let this "episode" threaten the success of my business. Radiation eventually got the best of me: toward the end I was so debilitated and exhausted I literally had to crawl up the stairs at night. As luck would have it, Bill was away in Princeton as a member of the Institute for Advanced Study, but he came home frequently to help. It was all a bit surreal, but I coped and, remarkably, I would later look back at having breast cancer as just a blip on the map. I never dwelled on it. It was during this period I had one of my most prestigious clients, the Association of Art Museum Directors (AAMD)—my client base! I will always be grateful for the incredible support and partnership of Charlie Pierce, director of the Pierpont Morgan Library, who was chair of the AAMD planning committee.

We became a nationally known, highly regarded museum consulting firm, specializing in strategic planning. Our clients eventually comprised some of the most important art museums in the country, including the Nelson-Atkins Museum of Art, the Philadelphia Museum of Art, the Phillips Collection, the Albright-Knox Art Gallery, the Baltimore Museum of Art, the Blanton Museum of Art, the Barnes Collection, the Georgia O'Keeffe Museum, and the Menil Collection. In addition to the Association of Art Museum Directors, we were also retained to lead another national organization, the College Art Association, through a comprehensive strategic planning process. Eventually we undertook senior executive searches for some of our clients.

Strategic planning was the hardest work I have ever done. I traveled extensively and facilitated high-powered meetings attended by CEOs of major corporations. I worked on planes and at night in hotel rooms, constantly integrating and synthesizing information for the next meeting. After 9/11, traveling was so much harder, adding hours to my already full days. Interviewing people and facilitating small work groups or large meetings was exhausting, and writing reports never got easier. This work demanded diplomacy and good listening skills and the ability to synthesize information quickly. It also took a mental toughness. Although the basic components of our process might remain the same, a hallmark of our work was to bring a highly individualized approach to each project. I had to listen carefully and be willing to challenge assumptions, remain diplomatic, and provide a forum to air different points of view, while at the same time never relinquishing the role of leading discussions. My people skills and my capacity for empathy, to understand how difficult change can be, were important. I was grateful when Douglas Schultz, the director of the Albright-Knox Art Gallery, generously acknowledged in the afterword of his institution's strategic plan: "She knew the difficult questions to ask and encouraged spirited debate," bringing to the process "her deep knowledge of museums and love of art . . . [and] her sensitivity, intuition, generosity, and good sense."

The 1990s and the first decade of the twenty-first century were a period of change for museums as they explored ways to become more a gathering place for their community as well as places to look at art. This effort to become more inclusive affected all aspects of an institution, including governance. Governance was one of the most delicate conversations I facilitated among board members as we negotiated together the complicated personal and social dynamics that are inherently woven into the governance structure. I was deeply impressed over the years by the astounding generosity, passion, and commitment in time of individual board members—a commitment to an institution and to a city which could be quite remarkable.

Strategic planning is in some ways like institutional psycho-therapy, and it could get very messy. I encouraged clients to push the boundaries of what they thought was possible for their institution and grapple with hugely important issues of identity. I was intrigued by the concept of institutional growth and how the power of a well thought-out vision for the future could motivate a new generation of donors and engage a broader cross section of a community. I had great faith in the process itself, and how the opportunity for staff and board members to sit at the same table to discuss an institution's future could be a powerful catalyst for ownership.

I remain grateful for the trust my clients placed in me. We worked way beyond anything resembling billable hours and became deeply involved with each institution. Each client was like the first time: what mattered was doing our very best. I have always had the tenac-ity and discipline to finish things to the best of my ability—this was a professional positive for my clients but a personal negative as many times I pushed myself to my absolute limits. The only way I survived the intensity of this work was through the vacations Bill and I took twice a year. I planned these trips carefully, and they were marked in my calendar like a board retreat. They could not be changed.

Our office environment, by Jennifer's description, was fast-paced, egalitarian, and intense, but we also developed a strong personal bond that transcended any work affiliation and made these years very special. Sometimes my need to get a report or a plan as good as it could possibly be was trying for all of us, but we all felt immense pride in the excellence of our final product.

Pat, Jennifer, and I, and later Phoebe Avery, shared a deep caring about one another that allowed us rewarding experiences of personal growth. We gave each other breathing room when we needed it. This was an extraordinary work environment, and I rel-ished the contradictions. We were dealing with high-profile clients, but my office, however spacious and separate, was still in my home,

and my three cats would find their way onto our laps and papers and my husband would sometimes inadvertently eat Pat or Jennifer's lunch that had been put in the refrigerator. When not traveling we dressed casually, and if I had a dinner party the night before, finishing leftover dessert would be Pat and Jen's first task in the morning.

We shared intimate moments in our lives, such as a breakup with a boyfriend, a wedding, buying a new home, or when my mother died in 2002. Pat was with me as I sat, lost on the office floor, trying to compose what I would read at the services the next day while looking at the slides I had shown for her birthday party just a year before. We developed a rapport of mutual trust and freedom among ourselves that allowed for creative brainstorming and problem-solving. I will always be grateful to them both for their commitment to excellence, their insightful questions, their dedication and incredible work ethic, and for their friendship. Something that surprised Jennifer and Pat was how very hard I could be on myself. I would worry if what I did was okay, was it good enough. I baffled them. They wondered why I, who they saw as incredibly good at my work, continued to question myself. Neither Jennifer and Pat nor other close friends could understand how someone as accomplished as they perceived me to be could need such constant reassurance. But I did. I was good at this work, but the difficult truth was that one big project going badly could ruin the business. It was a very small field. And knowing so kept me up at night.

Although I didn't consciously acknowledge it at the time, I believe I was inspired by my father's example. I, too, wanted my family to have a financial cushion and not to worry about money, and I was not intimidated by the idea of running my own business. And, for the first time, I was perfectly comfortable making the bigger salary, and so was Bill. I became increasingly independent, but this somehow helped us build a stronger relationship. We were thrilled to have a small but growing nest egg for the future, and as Bill often reminded me, I was making a difference in the museum world, and this was important work. Other than the fact I was working too

hard—some might even say I was driven—I was finally free professionally to work on my own terms. In regards to our lifestyle, we no longer lived like graduate students and enjoyed the occasional nice hotel on a beautiful beach in Hawaii and more adventurous travel.

My firm was active from 1993 to 2007, and my bookshelves still hold our situational analysis reports and strategic plans from some forty institutions, providing a unique view of American museums and the state of the arts during this period. I am immensely proud of my achievement and how I grew as a professional. I had the opportunity to do what I believe we all should try to do in this life: to realize fully our individual potential. But being me, on one level I still cannot fathom that I could do this, let alone what I actually accomplished.

Photo Insert

Page 153: Rothko, Mark, *Green and Maroon*, 1953, oil on canvas. The Phillips Collection, Washington, DC. Acquired 1957. © 1998 Kate Rothko Prizel & Christopher Rothko / Artists Rights Society (ARS), New York

Page 154 (top): Cézanne, Paul, *Madame Cézanne (Hortense Figuet, 1850-1922) in a Red Dress*, 1888-90. Metropolitan Museum of Art, NY. Photo: Public Domain

Page 154 (bottom): Cézanne, Paul, *The Basket of Apples*, 1887-1900. Art Institute of Chicago. Photo: Public Domain

Page 155: Goya y Lucenientes, Francsico de (1746-1828), *The Third of May, 1808*. 1814. Museo del Prado. Photo: Erich Lessing/Art Resource, NY

Page 155 (bottom): Goya y Lucenientes, Francsico de (1746-1828), *Portrait of Dona Antonio Zarate*. 1805. National Gallery of Ireland. Photo: © National Gallery of Ireland

Page 156 (top): Matisse, Henri, *The Moroccans*, 1915-16. Digital Image ©The Museum of Modern Art/Licensed by Scala/Art Resource, NY. © 2019 Succession H. Matisse/Artists Rights Society (ARS), New York

Page 156 (bottom): Matisse, Henri, *The Conversation*, 1908-12. The State Hermitage Museum, St. Petersburg. Photograph © The State Hermitage Museum / photo Vladimir Terebenin. ©2019 Succession H. Matisse/Artists Rights Society (ARS), New York. Digital Image: © The Museum of Modern Art/Licensed Scala/Art Resource, NY

Page 157 (top): Matisse, Henri. *Dance*, 1910 . The State Hermitage Museum, St. Petersburg. Photograph © The State Hermitage Museum / photo Vladimir Terebenin. © 2019 Succession H. Matisse/Artists Rights Society (ARS), New York

Page 157 (bottom): Piero della Francesca, *The Resurrection*. Ca, 1458. Pinacoteca Comunale, Sansepolcro Erich Lessing/Art Resource, NY

Page 158: Pontormo, Jacopo. *Deposition*, 1526-1528, Santa Felicita, Florence Photo: Scala/Art Resource, NY

Page 159 (top): Found probably near Susa, Proto-Elamite. *Guennol Lioness*, 3100-2900 BC. Private Collection. Photo: Public Domain

Page 159 (bottom): Sumerian, Cylinder Seal, Early Dynastic Period ca. 2700-2600 BC. © The Trustees of the British Museum/Art Resource, NY

Page 160: Rogier van der Weyden, *The Crucifixion* and *The Virgin and Saint John the Evangelist Mourning*, c. 1460. The John G. Johnson Collection, Philadelphia Museum of Art, cat. 334/335. Photo: Public Domain

PART THREE

Enduring Hearts

"In the midst of winter, I finally learned there was in me an invincible summer."
—Albert Camus, *Return to Tipasa*

PROLOGUE

In February of 2005, I turned sixty-four-years old. I had arrived at a comfortable place, contentedly living in a wonderful home and city, where we had a group of close friends and colleagues we enjoyed. Bill and I took long walks in Rock Creek Park and along the Potomac River, our more ambitious travel taking us as far as New Zealand and Turkey. Our home remained a welcoming gathering place, idyllic summer evenings spent on our large back deck. Our son had recently married, and Bill continued to publish and receive prestigious grants and awards, enjoying a productive and fulfilling career at the University of Maryland, where he was also chair of his department. My consulting firm had been immensely successful, and after years of money worries, we were financially secure and had learned to be good to ourselves. I was beginning to think about slowing down, contemplating what retirement might look like in a few years. I was ready to explore more private and creative endeavors and to get to know Washington better. And then, with no warning, our world began to blow up. Over the next several years almost every part of our lives changed. Things happened one after the other; it was the intersection of many dramas.

16. A Lonely Journey

Walking close to death is an experience that changes you forever. It can become so much a part of your psyche that you relive it time and time again in piercing detail, as if, in some ways, the emotions are the most intensely felt and vivid of your life.

In April of 2005, following a routine X-ray, Bill found out his heart was dangerously enlarged. His negligent cardiologist had failed to pursue the fact that his prosthetic aortic valve was nearly destroyed. It was a flashback to thirty years before. Bill went to bed, and I scrambled to find the right surgeon for what would be a complicated surgery. I knew how sick Bill was, and I was terrified. Death has stalked our marriage. Following Bill's surgery in May of 1975, we had a respite of twelve years. Then, just before he began teaching at the University of Maryland in the fall of 1987, his first porcine aortic valve reached its life span and had to be replaced. Thankfully this second open-heart surgery went well, although Bill remembered seeing a tunnel with white lights at the end and hearing a nurse in the ICU shouting, "We are losing him, get blankets!" Later, they were astonished that he could remember what had happened. I mention this because it is a reminder of the fact that Bill's heart issues threaded through our lives together, that indeed we did walk close to death several times, and the memory doesn't just go away.

While I waited for the date of surgery, I took long walks in Rock Creek Park near our home, walking a furious pace along a familiar path that paralleled the road because it wasn't safe to walk alone on the more isolated paths Bill and I enjoyed together. Sometimes I would "walk" in my mind to what I thought of as the "other side," to try to grasp what life might be like if Bill didn't make it.

We flew again to Boston for the operation, Bill sufficiently weak that we needed a wheelchair to navigate the airports and our arrival at the hospital. I was in the family waiting room when the surgeon paged me early in the operation. I raced across the room, almost tripping, to pick up the phone. Bill's heart was in worse shape than the surgeon had anticipated, and he told me he would also need to repair the mitral valve. Later, David and I stood near a window at the far end of the waiting room. He had been extremely comforting but now seemed less sure; having seen people leaving the waiting room crying, he realized those people could be him in a few hours. David had been a special, loving son, beyond what either one of us could dream or hope for, and I told him so; if his dad did not survive, he had nothing to regret. He had made his father unbelievably happy. I also calmly told him if Bill did not live, I would be okay. I had tried to prepare myself should Bill die. The intensity of these moments together, with its strange terseness of exchange, has never left me: the fierce sense of maternal protectiveness, and that unspoken acknowledgment of the love we shared as a family. Later David told me how much our conversation had helped him as he tried to absorb emotionally the possibility that his father might die and, just recently married, not knowing how his mother might cope.

Bill survived but with serious arrhythmia and ventricular tachycardia, stabilized over the next two years by a defibrillator and two ablations. The onset of congestive heart failure began soon after. We had made it through, but barely.

The whole experience was unspeakably traumatic for me, and a few months later I began to relive, in minute detail, the weeks

leading up to and after his surgery. I relived the long walks before the surgery, my anger at his cardiologist for being so negligent and at the surgeon for not reviewing his records until the last minute. I thought about how people cope in the moments before life-threatening surgery, how emotions get disassociated, how a sense of time is distorted as we struggle for normalcy. For Bill, it was a conversation with his anesthesiologist about something he loved, the artist James Barry, his life's work. I literally sat on the other side of a curtain listening, as if not there as he engaged in an animated conversation. Bill and I had said goodbye to one another as they wheeled him to surgery. I remembered how swollen his legs were a few days after the operation, knowing his heart had taken a big hit. I remembered our tears as I pushed him in a wheelchair down the hallway to our room at the Courtyard Marriott, near Peter Bent Brigham Hospital in Boston, where we stayed for two weeks after the operation as he recovered. I relived these moments obsessively over several months, very much like Joan Didion in *The Year of Magical Thinking*, where she returned to her husband's death, going over every moment and detail again and again, trying to make sense of what happened. Somehow in the numbness of the aftermath following Bill's surgery, the constant reliving of what had happened made me feel more alive. It was almost like a frisson to walk so close to death, and I kept returning. A year later I was to do this after my own surgery. I relived, sometimes in astonishing detail, the intensity with which I experienced my emotional and physical journey through cancer, and the acuity of my memory informs what follows.

We were in Rome in June of 2006 when I began to have gastrointestinal issues and an upper body rash with itching that no medication could calm. After we came home, my doctor ran a series of blood test that indicated dangerously high liver enzyme readings. An ultrasound revealed there were potentially serious issues, and a subsequent ERCP endoscopy confirmed I had cancer of the ampulla of vater, a rare and deadly pancreatic-related cancer,

for which the only possible cure is a Whipple procedure. The Whipple is an extremely complex operation in which the surgeon removes the ampullary duct and the bile duct, the gall bladder, a portion of the pancreas, the entire duodenum, and sometimes a portion of the stomach, and then, maneuvering around major blood vessels, uses parts of the intestines to reconstruct the necessary connections.

It was just a year since Bill's surgery. I was in total shock, and the only way I knew how to cope was to be proactive. I wanted to know as much as possible about my condition, what my blood tests revealed, what every procedure involved, and from the beginning, I demanded that my doctors be honest with me. Information empowered and calmed me. I was fighting for my life, and I was determined to win this fight. I immediately began to research the best surgery centers for this complicated procedure and learned that 20–25 percent of Whipple patients had complications following surgery. I understood almost immediately it was critically important to select a surgeon who specializes in this type of surgery and who is at a major center where there is a team who regularly cares for Whipple patients. I researched doctors and the day after the ERCP I was already in touch with one the best surgeons in the world for this procedure, Dr. Michael Choti, at the Johns Hopkins Hospital in Baltimore. My internist and my oncologist (who had treated my breast cancer a decade earlier) rushed tests results and pathology reports to Choti's office, and I had an appointment five days later. My home office became a command center with three phones ringing, and by some combined miracle of coordination by his staff, my doctors, the pathology lab at Georgetown Hospital, and insurance companies, I was on the operating table a week after my diagnosis. Things moved with an intensity that even I was not prepared for, and the hardest part was telling our son, who was living in Atlanta. He and his wife were expecting their first child in two weeks. I insisted that he not come up, that his place right now was with his wife. He couldn't bring himself to read about the

operation until the night before, and when he did, he later told me, he broke down and sobbed.

As we drove to the hospital at 4:30 in the morning, I told Bill I was strangely at peace. I had done everything I could to get the best surgeon and hospital in the country, and if I didn't have the operation I would die. As we waited behind a screen of curtains, I heard Dr. Choti say to the anesthesiologist, "She is young and healthy. This should be routine." *We can only hope*, I thought. They wheeled me down a corridor to the operating theater where, to my astonishment, they asked me to walk into the room. I was immediately immersed in what seemed like some stainless steel, ultra-modern chamber with equipment everywhere and nurses and doctors busily getting ready. I was helped up onto a narrow operating table with bright lights already beaming down. My powers of observation were still keenly alive. I lay down, stunned by this surreal environment, thinking this couldn't possibly be happening to me as my mind tried to absorb the visual details of this completely alien atmosphere. Even at this moment I was aware that however foreign this room was, it was the daily work-place of all the other the people in the room.

The next thing I remember was coming to in intensive care and my brother-in-law, Paul, shouting, "The margins were clear!" My poor husband had been trying to tell me this for hours, each time I reached consciousness, but I would immediately forget because of the medication I had been given. The first night in intensive care was hard, and I was in a great deal of pain but too weak to adjust the medication flow. The next day I transferred to a unit just for Whipple patients, and David flew up from Atlanta for several hours to see me. I was so grateful to have him there—I saw him standing at the end of the bed, and I said, "Come close, I need to smell you, to know I am really here, and you are really here." Dr. Choti stopped by daily. Remarkably I had no post-op complications, and I was discharged after six days. Before I left, Choti sat on the side of my bed and held my hand, reassuring me how well I was doing and how pleased he

was that the margins were clear. And then we talked about art and our lives and what I did professionally. It was a healing gift I will never forget, and it gave me hope. I will always be grateful to my compassionate and brilliant surgeon.

At home the pain was difficult to regulate at first—not howling pain, but strong pain deep inside my body. I spaced out the pain pills as best I could. The exhaustion and weakness were overwhelming: just standing up by my bed to urinate that first night at home was unimaginably difficult. I was so weak I shook uncontrollably, so much so I almost passed out, which could have been catastrophic in terms of the delicate nature of the surgery. Stitching together what is left of the pancreas is apparently like trying to sew together pieces of butter. Why we didn't have a nurse or caregiver watching me the first week is beyond my understanding even to this day. The next night I woke up screaming with the terrified face of my husband in front of me. He was sure I had seen death.

Five days after I came home, we heard a different kind of cry, the sound of our new grandson on the telephone, William Laurens Pressly, crying just minutes after he was born. The sound was unbelievably poignant but given the circumstances also surreal. Lying in bed together, Bill and I held hands in relief and bewilderment.

In the first few weeks home, I tried to get my head around the fact of just how sick I was. The weakness continued to be profound, and I sometimes felt like I was hovering over the room, completely detached from my body, thinking this couldn't possibly be my life. I found myself bargaining with some unseen power to please give me a year or two more. I couldn't die now. It was weeks before I could take a short walk outside without someone by my side.

Despite my excellent surgical recovery, my surgeon made it clear in my follow-up visit that "this was tough stuff" and my odds were only 50 percent. I wept as we drove home, devastated. Because of its rarity, there was little consensus back in 2006 or even today on post-operative treatments for ampullary cancer. I got a second opinion and then told my oncologist, Dr. Fred Smith, that I wanted

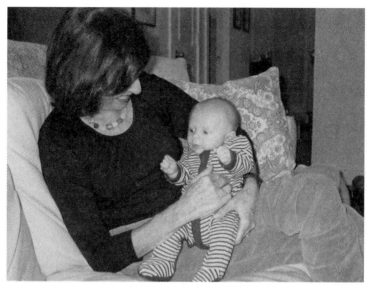

With William, Atlanta, October 2006

the most aggressive treatment he thought reasonable. Before I began,
I flew down to Atlanta to see William, my sweet grandchild. At eight
weeks, he was full-cheeked and so alert. I was thrilled and ecstatic,
and photographs document my joy. But seeing him also, inevitably,
made me sad. I so desperately wanted to see this child, my own flesh
and blood, as he grew and became himself.

In preparation for treatment, I was fitted with a cast-like
mold that placed me in a very precise position; my abdomen was
tattooed to direct the carefully programmed beams of radiation.
My compassionate radiologist asked me if I had any questions, and
I simply asked her, "How do I learn to feel again?" I was numb.
The drug Gemzar was administered intravenously once a week and
radiation five days a week for seven weeks. Radiation was remark-
ably debilitating to my already weakened body, and I soon became
too tired to even flip through the newspaper. I designated a "safe
place" in our house, our living room couch, where I could go and
regroup when I needed to, sometimes to sleep or simply to look out
into the world, our backyard. This safe place became my salvation,

its positive psychic impact enormous, a form of mindfulness, that calmed me.

It is hard to convey the overwhelming grayness of this period: the chemo/radiation treatment was brutal, and at the end I felt like a diminished version of myself, moving further and further away from the me I knew. A week after treatment ended, on a follow-up visit, I was shivering uncontrollably and could barely walk. A computerized tomography (CT) scan revealed I had acute radiation enteritis, a severe reaction to radiation, which had come close to burning a hole in my intestines. My body was starving because almost everything I was eating was passing rapidly through my digestive track and not being absorbed. I was put on a special diet of bland foods for two weeks, what I called a white diet because the strongest hue was a yellow banana, but I continued to lose weight. As I lay prostrate on a sofa in my darkened office, I began to understand what it might feel like to be dying: each day you feel weaker, one's frame of reference narrowing—the lens you look out of onto the world gets smaller and smaller, and then one day you are no longer there. I write this not to be dramatic but as a reminder of just how sick one can feel and STILL get better.

Three months of chemotherapy followed, which I tolerated relatively well. There were delays because of low blood counts and my hair thinned, but I was aware that there were so many people looking so much worse than I was. I also understood vividly the meaning of chemo brain. I had trouble remembering things and understanding, sometimes, what people were saying. I heard the words, but there was a delay in processing them. I still experience a little of this today.

Then my treatment was finally over! But what I didn't fully grasp at the time was that the long tortuous wait had just begun. I had a three-to-five-year window: if the cancer didn't recur, I had a surgical cure. The first post-treatment CT scan was the critical first test, and I drove alone to the hospital, not telling anyone, my heart pounding, to pick up the results. I was terrified and

shaking as I opened the envelope. The results would tell me if the cancer had returned, which would be a death sentence. The report read, "Seven months post-surgery, CT is clear and normal and no evidence of metastasis." I was shaking so much I could barely remember my husband's number. What followed were CT scans at three-month intervals and eventually at six-month intervals. This ritual of literally opening an envelope to find out whether I was going to live or only have a short time left only got harder. It was equally stressful for Bill.

I was aware, almost from the beginning, of the intensity with which I was processing this experience, and I began to write down random observations. I started to look beyond myself and how I might help others get through this lonely journey, how I might share some of the insights I had gained along the way. In 2006 there was little information available to help patients anticipate what was ahead or understand if how badly they were feeling was normal or something to be concerned about. With no guideposts I, and many like me, simply soldiered through. And we waited. I became aware, especially during the treatment period, that patients are always waiting. Waiting rooms, especially radiation waiting rooms, become the communal gathering place for cancer patients. We sit there in our blue-and-white hospital robes and wait, sometimes accompanied, sometimes alone. We look at the same old magazines every day, and at each other. I remember the depressed, angry husband whose wife was so completely into her illness she was oblivious of him. There was the daughter who brought her mother some distance every day, good-natured but acknowledging this daily commitment of time was her cross to bear, and a harried husband who always carried notebooks filled with his wife's tests and reports.

But the person I remember most was a chemist with ear cancer. He came over to me one day in the now-empty waiting room and asked, "How do I cope? How do you get through this?" I told him it was a lonely journey, but one of the ways I coped was by finding a place in my house to lie down and regroup: my safe place. I

also told him to try to find small pockets of pleasure in the present moment. For me it might be my cat, Rocky, lying on my chest or walking alone in the park, where one day I unexpectedly found a group of tiny mushrooms emerging after a heavy rain. The sunlight made them look like a fairy world, an image I can still see. What I didn't know at the time was that I was practicing mindfulness, taking genuine pleasure in very small things, in the moment. It was key to my recovery. The last thing I mentioned was that for me, at least, it was essential to be open and honest about what was happening. He looked at me in despair. "My wife is in complete denial," he said, "she doesn't want me to even tell our daughters." They called my name. When I finished radiation, he was still there. I took his hand and said, "You have to tell your daughters—they deserve to know and to help you; you deserve their support." It was a poignant moment of small kindnesses.

I am a positive person but also a brutal realist, and I learned to live in what I called parallel universes, understanding that almost every decision I made was informed by the dual realities of the two paths I was walking down—one where I would be cured, the other where the cancer returned and I might have only a year to live. This approach helped me enormously, but despite what my surgeon called my "high-level" coping skills, very little could mitigate the loneliness of my journey.

People cared about me more than I had imagined; friends were considerate and deeply concerned, some more comfortable than others in asking questions beyond "How are you feeling?" I was grateful for their sensitive inquiries, especially from my New Haven friend Sally Tyler, who let me know it was safe to talk, that she really wanted to hear about the details of my treatment or how I felt or how Bill was coping. I know my directness and openness to speak in detail about my medical condition, treatment, and prognosis made it easier for some of my friends. But it was difficult for Bill to see me so ill. I wasn't demanding, but it was terrifying for him, and he was understandably depressed as he tried to cope with a dramatically

changed world, especially when I had always been the healthy one. Bill and I didn't talk very much about this, but I felt we were totally in sync, both of us trying to be stoical and get through the day and be there for each other.

About eight months post-surgery, I slowly ventured from the secure cocoon of my home back into the world, at first being bombarded by sensations and stimuli that used to be normal in my life but now felt overwhelming. That spring, by some serendipity, I finally got the community garden plot for which I had previously been waitlisted. Sometimes I think it saved my life. I went to the garden almost every day, sometimes walking, sometimes by car. I spent hours there gathering strength, healing emotionally, as my mind went off into Zen-like places. I took intense pleasure in my first spring planting when multicolored lettuce leaves and Swiss chard were framed by broccoli plants, a surprisingly beautiful tableau. I enjoyed the physical labor, and I rarely wore gloves, preferring the feel of the dirt on my fingers. I was immensely comforted both by the work and the beautiful setting on the edge of Rock Creek Park and adjacent to the pastures for Park Police horses, whose manure I used to fertilize my garden plot. Being immersed in the cycles of nature helped release the fatigue and stress not only of the last year but of a lifetime of working. I was beholden to no one, only myself and my vegetables. It was immensely restorative. I saw birds I hadn't seen since I was a child, like a Baltimore oriole, and I listened contentedly to the horses as they snorted and neighed. I didn't worry when I was gardening. Gardening continues today to give me enormous pleasure and is a source of creative endeavors. Nurturing a garden and being able to pick tomatoes or lettuce or green beans and, now in Atlanta, peaches and plums, never loses its thrill.

Coming up to one year after surgery, it slowly dawned on me that despite my optimistic attitude and newfound energy, nothing was the same. Nothing: not the way I felt emotions, not how I related to the people I love, not my body, not the way I ate, not how I experienced time or the present. I was a different person on a

different journey. Except for the nine-inch scar down my abdomen, my body looked the same, but my inner self was so different. I had to learn to function all over again in what was for me a changed world. I sometimes felt like I was watching my life from a different time zone. I was also more direct; Bill said I had lost my filters. Some appreciated this directness, the "realness" of me, as one friend put it; others, including my son and husband, missed my former, subtler style. I was quicker to snap back or bristle. I was at David's house in Atlanta in September of 2007, when Luciano Pavarotti died of pancreatic cancer. Not only was Pavarotti's illness and death uncomfortably close to what I was experiencing, I also had a deep emotional connection with him and his singing. David knew this, and when I walked out onto his screened porch, deeply shaken, he followed me and put his arm around me. I looked at him and said, "This is the hardest thing I have ever had to do, not knowing how this will end." He held me close, and it was so comforting. We just stood there, together, for a while.

I had changed in other ways as well. I realized I was ready to retire. I was no longer the dynamic public persona who had thrived before surgery, and I had no desire to continue museum consulting. I still had a long way to go for a full recovery, and after fifteen successful years I was ready to retire and live my life in slow time, without deadlines and intense schedules. I finished a few projects, said no to others, and quietly closed the door on my professional life. I never looked back.

During the long months, while I recovered and waited to know my fate, I summoned up a toughness and resilience; I tried to bring order to my existence and use my time productively. I not only researched my family history, I also turned to the Pressly family. What started as an interest in the first few generations of Bill's Scotch-Irish ancestors who settled in South Carolina in the eighteenth century evolved into a scholarly, contextual history of the backcountry. It focused on the area now forming part of Abbeville and Greenwood counties and how it evolved from a newly settled

frontier into a center of wealth and power in the decades before the Civil War. The resulting publication, in 2016, of *Settling the South Carolina Backcountry: The Pressly Family and Life Along Hard Labor Creek, 1767–1850* (BookLogix) was in many ways an ode to my father-in-law. Maybe I needed to do this first before I could think of delving deeper into my own past.

But at around eighteen months post-surgery, these projects came to a halt; something else happened. As I regained my strength and CT after CT was clear, I let down my protective warrior shield that had kept me strong. I became more fragile and lost my traction; I no longer trusted my intuition, which had always guided me so surely in the past. I realized the degree to which the experience of cancer had destabilized me, had stripped me to my core. I was not prepared for the depth of the depression that followed. My worldview became darker and darker—I felt like death hovered everywhere, and the fear of recurrence haunted me in the pit of my stomach. I needed help.

My wonderful oncologist, Fred Smith, was always watchful, reading every CT scan himself, reviewing blood tests carefully, encouraging me every step along the way. He assessed my stoical nature and didn't prod me. Our visits were sometimes short, but when I told him I was deeply depressed, he told his staff to hold the calls and talked to me for some time. He understood depression and knew I needed help. I began to see Dr. Lauren Hodas, who specializes in people with serious illnesses. She helped me immensely to deal with my new reality and my needy side, which had reasserted itself. I no longer wanted always to be the strong and wise one in the family, the leader, the one who could navigate through any problem, the one who, as one friend said, she could always count on "to be wise and honest." I remember so clearly sitting in Dr. Hodas' office discussing my vulnerability and what I described as my insatiable neediness. She seemed startled. "Your insatiable neediness?" she repeated. I said, "Yes, that is what it felt like after all my defenses were down." It startled us both.

The sessions and changed medication helped me calibrate back to a person I am comfortable being, albeit more subdued and inner focused. The treatments and the fight for my life, and the sheer magnitude of change I experienced completely knocked me off-center—destabilized the world I knew and with it, my trust in myself. I learned to accept that in many ways it did the same for Bill and David, especially David. He had known for the most part a strong and wise and kind, giving, and emotional mom. That woman was the mom he relates to. To see me vulnerable, needy, misfiring, anxious, even snappish threw our relationship off-kilter. I also came to realize it was okay for the strong mother and wife to ask for help and to assert my own needs unapologetically and be more protective of myself as my father-in-law always wanted. It is difficult to explain the change, but I am a different self, and I am certainly more introspective, subdued, perhaps detached, and it is harder for me to be spontaneous.

One miraculous day in May of 2009, my oncologist, Dr. Smith, looked at me after reviewing the latest CT scan and said with absolute confidence, "I think we are looking at a surgical cure, not a remission. I have watched you. You have worked very hard to get well. You should be very proud." I didn't expect to know my prognosis for another year, and I was speechless; it took hours to penetrate fully. Later, Bill and I just sat in the house holding hands and each other. The feelings were beyond words.

But I was profoundly changed. For years afterwards, I have thought of my life in a construct of "before cancer" and "after cancer." I initially even thought of titling this memoir *Before and After.* It has been hard for me over the years to explain how I have changed, but I can see now that I had been in the fight of my life and I survived in part because I focused totally on myself. I was no longer the caregiver, the one who immediately thought "How can I help?" even to a casual acquaintance. I was in totally new territory. Maybe this is why I felt so different, something brought home to me in a startling manner when, a month after I was declared cured, Bill

called my name and said something that I didn't hear because I was drying my hair. I replied, "Are you calling me?" and he retorted, "You are Nancy Pressly, aren't you?" I said instantly back, "No, I haven't been Nancy Pressly for three years." Perhaps this is how I moved with little hesitation into my next life.

With Caitlin, Atlanta, Summer 2010

17. Becoming Meema

Three weeks after I received my wonderful news, I answered the phone and told Bill to get on the other line. Something was clearly wrong. David called to tell us that his wife was struggling with alcoholism and the situation was incredibly serious and dangerous. This had been going on for some time, and he had been coming home early from work for months to help take care of the children. We had assumed from what we observed that there was some sort of drinking issue, but David had protected us from the severity of the situation. We were stunned. We had no experience with alcoholism and were entering uncharted waters. Our grandchildren would soon turn one and three.

Initially, I flew down to Atlanta several times in early summer as an emergency backup, eventually staying for over a month in August, when David's wife received in-patient and out-patient treatment and then again in mid-November, when she entered a thirty-day, in-patient rehabilitation program, followed by one week as an outpatient. I remember that first August when David and I sat on the living room floor in numb silence, thinking, *Oh my God, now what do we do?* We had two very young children to take care of. But I soon saw my son was an amazing, calm, tender, and loving father, with his children deeply attached to him.

During this period of frequent visits, I began to grasp more fully the magnitude of what had happened as I learned about repeated incidents and emergency room stays. Neighbors and friends told me horror stories, and for months I found empty bottles and glasses with liquor residue hidden all over the house. Despite the treatment programs, things didn't get better.

David struggled to figure out what his options were and what was best for the children. He was terrified about their future and wanted to be sure he had done everything he could to support his wife's treatment and to save their marriage. But things did not improve; the cycle of drinking followed by contrition continued to repeat itself. Following a particularly rough patch and much soul-searching, he finally filed for divorce in early April of 2010. She entered a six-month resident rehabilitation program, and David was awarded temporary full custody and a court protective order. After a sixteen-month divorce process, he was awarded primary physical custody.

For the next two years, I lived above my son's garage in a space smaller than my New York graduate school apartment. I had to learn to use a new type of car seat and to open and close a double stroller while holding a one-year old in my arms. My time in Atlanta was relieved by regular short trips home to Washington and much-needed vacations with Bill, including two cruises in the Mediterranean. My dreams of indulging in slow time were on hold, my new life very different from anything I had anticipated. I had no idea what the future would be, but I was very much needed.

I became a mother again, in totally new ways, to my son and to my grandchildren. William and I had first bonded during his babyhood when I began reading to him from *Mr. Brown Can Moo! Can You?*, one of David's favorite books as a child. I would always make a big deal about the page where Mr. Brown knocks on the door. We would pound the page with our fists. As he was learning to talk, William decided to call me Meema, and Bill, Geeda. Whenever David would say my name, as a toddler William would run for the book and

open the knock, knock page. Now, snuggling in my arms, he reveled in the quiet attention I gave him, and we settled into a loving routine as we read books and built every conceivable structure with his large wooden blocks and enjoyed the mess of making papier-mâché creations. When I would return from a trip to Washington, William would race into my arms, a huge smile on his face. He was a beautiful child with a joyful personality. With the chaos removed from his life, William quickly became more outgoing and exuberant and less anxious. According to his preschool teachers, he became another child, displaying once again what they described as "a smile that lights up the room." They marveled at the change, and David and I were so relieved to see his joyful quality and spirit renewed.

Caitlin began to come out of her protective shell and blossom, revealing an engaging smile and sweet temperament. I got down on the floor and taught her how to crawl, and we played with her toys and stuffed animals that she dearly loved. Totally a Daddy's girl, Caitlin began to bond with me as a caregiver as well; I still enjoy returning to pictures of us in which she is full of smiles, curled up in my arms. This seemingly reticent child, who had simply been staying beneath the radar perhaps for self-protection, began to evolve into a totally amazing firecracker, feisty, lively, a beautiful little girl with dazzling wavy hair, determined as only a toddler can be to do everything her brother did. She and I would "cook" feasts together with her toy kitchen and serve everyone, including the cats. And of course, we sat on the floor and had our tea parties. I became her Meema too. Caitlin and I snuggled—for both children, there was always snuggling time—and we played ball, and I would take her to the playground where she could swing forever. Many afternoons I carried her up the stairs to finish her nap after she fell asleep in the car when I picked up William at preschool. We have come to share a special bond, enjoying each other's silly humor and love of board games and especially a deep trust and tenderness and love.

I understood the weight and depth of this involvement and attachment, and how I had become a fundamental pillar of the

children's emotional lives. This was a huge responsibility, and as one year passed and then two, there were times I felt a kind of panic. I hadn't taken care of kids in so many years, would I know what to do? Could I manage this physically? It was exhausting, but all my maternal instincts were reawakened, and I felt such a deep, loving bond with the children. They were the focus of my life, and I jokingly said to a friend at one point that I felt like I was ready to lactate again. But it was not an easy period, and I was glad I was there to help and hold William, this unbelievably sweet child, as he tried to process at such a young age and with touching innocence the trauma he had experienced.

I helped nurture and hug these children when they needed it most, and David and I built a schedule of regularity and calm expectation, enjoying dinners I prepared and nightly rituals like reading them stories before they went to sleep, enjoying their heads heavy on my shoulders and rubbing their backs. I pushed their stroller up steep hills, which were the only walking routes in this neighborhood, to visit playgrounds several times a week. I marvel how I did this because I now walk up these hills by myself huffing and puffing! We made art projects, went to museums, and read books. We had our favorite books to read at night, especially *Goodnight Moon* and the *Little Engine That Could* and *Scuffy the Tugboat*. As they grew older, after Bill and I had moved to Atlanta, *The Fire Cat* and *The Little House,* with its fabulous illustrations, became our favorites.

I made two books for William that first year, adapting existing texts by adding words and pictures so the stories were about him. William would reenact endlessly the book I wrote about the two of us going to London. In fact, William and I made many imaginary trips as adventurous fantasy-play partners that first year, when Caitlin was still a young baby, with our favorite destination being Paris, where we would meet Curious George. He and I would sit on a bench in the dining room as I took off and "piloted" the plane. One time I made a "mistake," and we landed in London, which William thought was hilariously funny. We would roll our suitcases into the

yard, which became Paris, and ride an "elevator" we created up the Eiffel Tower. We would also sit at a "café" and make up silly plots with waiters spilling stuff on us. In the park we found a place to "fish," and I would fall into the make-believe river and get "wet," which I could repeat endlessly for him.

So, I became *Meema,* a whole new persona. Even some of the neighborhood children and some of the children's friends still call me Meema. Being Meema was also a way of being accepted in the circle of younger mothers. Rather than call me Nancy, they called me Meema with affection and sometimes admiration. I remember one mother saying she would be so happy if she looked like Meema when she is my age. I will always be grateful to these young women who allowed me to be part of their lives and their circle as I brought the children to playdates and we talked together while we waited to collect them from preschool. I rarely felt like a grandmother. I was a new entity, Meema. Even my son and Bill still call me Meema. And as tired as I was, I reveled in this gift of domesticity and maternal pleasures.

During these first years, David learned to focus on what he could control and be the most loving presence possible for the children and not to worry over what he couldn't control. The children's mother gradually reentered their lives, and they slowly began to rebuild a relationship with her. It was not an easy process, made more complicated by the tensions of the ongoing divorce proceedings as both parents fought for custody. The emotional toll on me during the divorce was huge. The conflicts and legal machinations were unbearably stressful as the future of the children lay in the balance. David worried about the long-term safety of the children and the effects of the trauma they'd experienced, which indeed would surface a few years later. And I worried about everything: my son and the toll on him, where Bill and I would live, the stress of the divorce proceedings, if we had enough money, and what the future would hold for the children. The stress, especially following my bout with cancer, was sometimes difficult to navigate, and the vacations Bill and I took were essential.

Somehow David and I kept it all together and managed not to be fully subsumed by the relentless anxiety and worry. We also maintained boundaries so we could survive together. David sometimes marvels how we managed through those two first, difficult years, but we did, and we built new bonds in an adult relationship. He has told me so many times how grateful he was for my selflessness and willingness to do anything for the children and for him, and how guilty he felt that, when I was finally able to retire and enjoy our beautiful house in DC, I ended up living above his garage. I have reminded him that I was doing what I wanted to do, and this was where I belonged; helping him take care of the kids may be the most important thing I have done in my life. We made it work, and I will always be grateful for the support of his neighbors, especially his friend Buck, who joined us for a drink often and enjoyed my cooking.

This was a difficult period for me in other ways as well. I missed my husband. We were both lonely, and I, the ultimate nester, was mainly living in one city while my things were in another. It became increasingly clear that Bill and I would be moving to Atlanta. During this period Bill was diagnosed with prostate cancer and underwent radiation, which he tolerated remarkably well, but I felt so torn between my two families. I sought help to confirm what we both already knew: the children needed me more.

After Bill retired, we moved to Atlanta permanently in June of 2012. We found a newly built house just up the street from David that had everything I wanted: high ceilings and modern, open spaces filled with light, a spacious and well-designed kitchen, and a backyard I was able to transform into our own lush Eden, winning Yard of the Month on two occasions. It is a special home that we constantly receive compliments on, and I was thrilled. The house gives me great pleasure, suiting the casualness of our lifestyle and with spaces to display our ceramics and the objects we have collected from our travels. Living so close to the children made it an almost seamless transition from living with them, and I continue to be very

much part of their lives. We began a new life, and it was good to be a whole family again.

But alcoholism doesn't just go away; it is a lifelong disease and the debris left in its path continued to be part of our lives. The best way I knew how to cope was to learn more about the complexities of this disease, much as I had for Bill's heart issues and my own battle with cancer. I needed to understand better what we were experiencing and what might lie ahead. Early on I attended an AA meeting and I read medical articles and personal accounts. Knowledge helped me navigate my pain and comprehend how loved ones can become partially desensitized to repeated lapses and irrational behavior. Moved by compassion and wanting to help, they can find themselves tittering on the slippery slope of continuing to be an enabler. It is very hard to grasp that only the alcoholic holds the power and will to get better and remain sober.

The children have understandably been deeply affected by their mother's illness, and a few years back David had to be totally honest with them so they could comprehend what was happening and what they had experienced when they were younger. With the help of a wonderful child psychologist, David has led them through their slow acceptance and understanding of the reality of their lives while at the same time giving them a space to love their mother. Therapy can help children with an alcoholic parent develop skills to assess their environment for danger. It can also impress upon them that none of what is happening is their fault, neither now nor in the future, and a parent's health is not their responsibility. I am in awe of their remarkable strength and resilience, and I respect my son for trying to ensure his children can sustain a positive relationship with their mother. But his priority is keeping them safe, and I know that trying to find the right balance is harder than anyone can possibly imagine. The children have a profound bond with their father, whom they trust and deeply love and whom they can confide in and be honest

with about their feelings and fears. I can look at these children and know how extraordinarily brave they have been and marvel at how remarkably kind, empathetic, resilient and well-adjusted, and simply fun children they are. I am so proud of them.

We have not had an easy time, and there are episodes over the last several years that, out of respect for my son's and grandchildren's privacy, I am not comfortable sharing. But they are embedded in my psyche, and I would be less than honest if I didn't admit to my own terror and pain and sadness. It has occupied so much of my emotional space and sapped so much of my creative energy, often leaving me helpless. I think I will always carry a sadness with me. A year ago, while looking at the interior of a beautiful Richardsonian church in Birmingham, Alabama, I received a troubling text from David. I was suddenly overcome with emotion and heartache, and for the first time in years, I began to weep quietly. I signaled Bill to go on with the people we were with, that I needed to stay in the sanctuary. I, a nonbeliever, took a seat. The Methodist preacher came over and welcomed me before the service. I needed a spiritual connection, and the beauty of the architecture and the kindness of the people provided it.

Being Meema, at least for the first several years, was a lot more than being a grandma, and I understood the complexities of that role and the feelings it may have evoked in my former daughter-in-law. I have never spoken badly about their mother to the children; my role has been to love them, care for them, and share in the joy of their lives and be an unconditional loving and stable presence. The concept of family is complicated, and, despite everything, I have felt compassion for her, even when the situation has been awkward as I picked up a crying child.

I have been asked so many times, how could we give up our life in Washington, just pick up and move to Atlanta? I can honestly say there was never a moment of doubt or hesitation. This is what we wanted to do and where we belong. Yes, we gave up a network of friends; yes, we gave up a house that had given us so much pleasure, and a circle of colleagues that would have continued to

enrich our lives. Moving was difficult, and we regret not being able to make more friends in Atlanta, but Bill and I have been so rewarded and have made an extraordinary difference in the lives of our grandchildren. It has also been an amazing gift to be able to step back in time and become a "young" mother in new ways, as I help my son care for his two beautiful children. Their deep attachment to me is so comforting. There were times when the children were younger and slept overnight at our house when I would read them stories, and I would say to myself, *I never thought I would feel this bliss again.*

Sitting at the kitchen table not too long ago, laughing and finishing dinner with our grandchildren, Bill and I felt overwhelmed with emotion and the awareness that our home with their Meema and Geeda will be part of their memory, part of what they bring forward into their adult lives. We have given them a happy and safe place filled with a steady, unconditional love, a place that provided boundaries and structure but also let them push back and test what limits meant. It is a place where we all can be incredibly silly, where Bill roughhouses with them, which they still relish, and this cultivates their sense of humor. Our home is their home, too, an essential, loving environment where we have nurtured their imaginations and tended to their tears. Living up the street from them, we have provided a haven in the profoundest of ways. We have taken glorious vacations together every summer and feel so lucky to have been so much a part of their lives. It has been a precious gift. My granddaughter is an extraordinary athlete—an amazing tennis play and basketball player. She is empathetic, feisty, caring, and loving. We share a wonderful closeness and silliness, and she continues to surprise me with her wisdom and common sense. Now eleven, she is starting to become a beautiful young woman. I adore my handsome grandson, who has an amazingly sophisticated sense of humor, is a great golfer, and is a wonderfully kind, polite, sweet, and caring human being. He constantly surprises me with his insightful observations and good-naturedness. And I am so grateful that he still lets me hug him.

*Celebrating's Bill's Distinguished Alumni Award
at Westminster Schools*

William and Caitlin with peaches from my garden

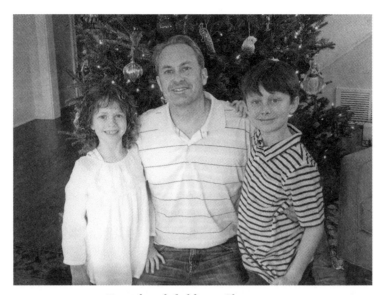

David and children, Christmas

My camera is never far away, and I have so many images of my grandchildren that keep these moments alive not only for me now but perhaps for them and their children in the future. Hopefully, I will be the beloved grandparent they so fondly remember, and these images will trigger their memories of dinners out, of going to Yogurt Land and stopping for milkshakes at Chick-fil-A, of trips to Costa Rica with monkeys climbing on our terrace, of vacations in Canada, Washington, DC, shelling on the beach, and hikes in the North Carolina mountains, of playing with our cat, Thomas, of Caitlin and I getting our nails done, of baking gingerbread cookies every Christmas and awesome Easter egg hunts, and all the wonderful holiday meals.

Bill and I, along with Paul and Jane, represent what the continuity of family can mean. I am glad, too, that they continue to see their mother's siblings and their cousins. Caitlin and William have seen their father with his parents working together to address the many crises that have been threaded through these past years. I am grateful David has let me brainstorm with him, but we also

respect boundaries and differences. We have been and will always be our son's backup system. David, for the most part, has been a single parent, and we have helped in whatever way we can, from grocery runs and buying clothes and laundry to picking the kids up at school and helping with homework, to taking care of them so he has free time. The three of us have enjoyed a special kind of bonding and trust, and we have gotten to know one another in ways that might never have happened.

Bill and I are justly proud of our son. He has been a remarkable father, a nurturing and loving parent with equally strong paternal and maternal instincts. He makes snacks for school and dinners, sets up playdates and organizes after-school and summer activities, and makes doctor appointments and helps with homework while enjoying a successful career. And he has faced personal adversity with courage and grace. I hope my son can move beyond this long and fraught episode in his life. My handsome and engaging son is not at a loss for girlfriends, but I hope someday he will want to find a soul mate and open himself up again to sharing his life with someone else.

Because we had only one child, we shared over the years a certain intimacy and openness with David that might not have been the case if we had had more children. My son has been the most amazing thing that has happened in my life. I adore him and respect him and admire him and sometimes hardly know him. But in moments of closeness he tells me what he feels, and it is always something that I cherish more than anything that anyone else could say to me. A couple of years ago before a trip, we were sitting on the porch in Atlanta (it seems this is where we always talk), and, as I do before big trips, we reviewed where the will and safety deposit keys were. We talked about how well he is managing with the children and how proud I am of him. And then he switched the subject. He told me how much he appreciates who I am and what I have done for him and the children, and that Bill and I will always be part of the children's memories. He looked at me and said, "I admire your energy

and work ethic, and I tell people about you and what you achieved professionally. I remember you taking the bus and then the metro to work and back, coming home around six and cooking a real dinner." He stopped for a moment and then said, "I should tell you more often how much I love you and how appreciative I am." I will never need more than that.

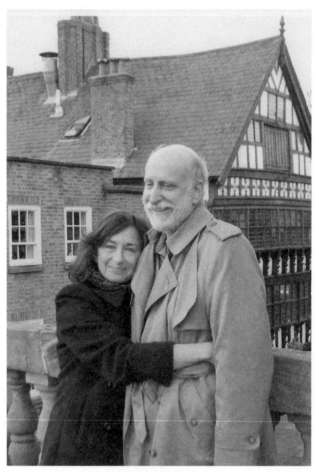

In England

18. Epiphanies

As Bill and I approach our fiftieth wedding anniversary, I am so grateful for how in some extraordinary way our hearts have endured together physically and metaphorically. In the summer of 2017, Bill's third aortic valve replacement started to fail. Because of the accumulation of scar tissue, we knew a fourth open-heart surgery was not a possibility. I had dreaded this moment for years. But fortunately, thankfully, miraculously, he proved to be a candidate for a remarkable new procedure at Emory University Hospital called TAVR (transcatheter aortic valve replacement, a work of art in its own right). There was no other option if the TAVR didn't work, but it did! Bill, as usual, was amazingly brave. His heart, despite everything, endures, but his progressive congestive heart failure has entered a new, more serious stage with occasionally frightening moments. Together with love and some sadness, we are slowly processing our new realities. While plane trips are a thing of the past, we can still visit by car sites that interest us and enjoy many simple pleasures together. We continue to write, working in our separate studies across the hall from one another, understanding each other's need for quiet, uninterrupted time. We share a solicitous and caring tenderness that is immensely comforting. As I was finishing this manuscript, Bill was diagnosed with lung cancer and remarkably

came through a lung wedge resection with a stable heart. He is my ironman, crazy brave and crazy lucky!

Sometimes I am amazed at my own resilience, my ability to adapt and cope, to be knocked flat with exhaustion and anxiety, but I am also determined to bounce back, to not succumb to the stress. It's not that I don't stagger and get depressed; I absolutely do. Often it is the simple things that bring me back: a gorgeous blue sky, or vegetables beginning to grow in my garden, or one of my grandchildren saying I love you, or the sensual pleasure of my cat, Thomas, sprawled asleep on my chest. I continue to find beauty in my life and a special contentment in indulging myself with new adventures, most recently taking up pottery and throwing on the wheel, grateful for new friends. It has been a steep learning curve, and I go to the ceramic studio obsessively, amazed as I throw bowls and vases that begin to express my own aesthetic.

And Bill and I have certainly enjoyed the last ten years, taking some of the best trips of our lives. It is hard to explain why my memories of travel with Bill and our looking at art together are so important, but they are integral to who we are as people and the contemplative values we share. There is a deep intimacy to how we share what we see and think, a kind of special trust, and it is a profound bond that seems to deepen with the years. Since my illness, my anticipation about future trips and exploring new places has only heightened. We have gone to Berlin, Athens, Vienna, Prague, Stockholm, and places like Sicily, Spain, and Morocco, and visited again London, Tuscany, and northern Italy. We have taken cruises to St. Petersburg and the Baltic, the Greek Islands and Costa Rica and returned to Rome, probably my favorite city, three times.

But there is another element here as well. In retirement, these trips have taken on new meaning for me: rather than being respites from intense work schedules, as they were in the past, they have become crucial learning expeditions, essential breaks in the routine of caring for my grandchildren, necessary to nurture my intellectual life and my inner self. There is a new intensity to the way I absorb

what I see; I frequently take in a site with what I can best describe as a hyper-real focus, almost as if I am experiencing time at a different pace, as if I had reset my biorhythms. I process what is before me like a slow-moving motion picture camera, trying to absorb every detail as well as the whole, whether it be a Tuscan landscape, the ancient ruins of Mycenae, or a cityscape—such as standing on a street in Vincenza lined with sixteenth-century Palladian palazzos—or spectacular architectural interiors such as Michelangelo's Medici Chapel or his Laurentian Library. I retain it with vivid clarity, not only the visual experience of those moments suspended in slow time but also the intellectual and emotional responses. I come back totally energized; the encounter can occupy my thoughts for month. I often read more specialized books about what I have seen, enjoying the pleasures of research much as I did as a graduate student.

While I plan our trips carefully, often devoting months to planning, I also look forward to the surprises that come when traveling, aware that despite all the brilliance of digital photography, one must see a work of art or cityscape or ancient sites firsthand. Nothing could prepare me for the experience of climbing down steep steps into underground Etruscan tombs in the isolated site of Tarquinia, north of Rome, to see remarkably preserved, colorful seventh- and sixth-century BC frescoes celebrating meaningful activities to be kept alive in the next life. Standing in these isolated tombs by myself and at the nearby necropolis known as Banditaccia in Cerveteri was one of the most extraordinary days of my life. I was almost disorientated walking in the buried "city of the dead" at Cerveteri, trying to contemplate that the grass-covered mounds and "streets" replicated the nearby ancient Etruscan city, where their owners had lived. I looked at the room-like spaces of these tombs, some with stone chairs for the living, and thought how these "dwellings" were once filled with luxury objects—some now housed in the nearby museum.

Likewise, I could read about the Moroccan city of Fez, but it was only when I stood in a narrow street of its ancient medina in front of a tiny hovel of a shop that I could grasp, if just for a

moment, how medieval Fez must have functioned seven centuries ago. I never truly understood what a Jewish ghetto meant until I was in Prague and saw the circumscribed space of the small Jewish cemetery, with gravestones piled upon gravestones, some sunken, others broken because there was no other place for people to be buried. Years ago, we stood on a promontory, part of the ancient city of Pergamum, gazing at the immense vista before us, once part of the Roman Empire. We walked through the ruins and rubble of this great city that once contained the magnificent Altar of Pergamum, now in Berlin. There were no guards or fences or entry fees, just the reminders of former glory and the passage of time, more moving in a different way from the much more intact city of Ephesus. No photograph or amount of reading could evoke the power of that moment.

During a recent trip to Ireland, we climbed a steep hill to visit the isolated Neolithic site Loughcrew. There were very few people, and before us was an immense vista, a 360-degree view with darkening clouds signaling the rain we would experience later in the day. We stood among small burial mounds that encircled the larger cairn, created by a hunter-gatherer society between 3500 and 3300 BC. A site ranger let us climb into the cruciform passage cairn with its two small side apses and carved back stone illuminated twice a year, in the spring and fall equinoxes. The interior sides of the passage were carved with remarkably preserved ancient symbols; some are similar to those found on Neolithic buildings on the Orkney Islands and temples in Malta. Across the way on private land was another similar steep hill surmounted by a large passage cairn with a carved back stone. Together these cairns mark some recurring sacred ritual and being there was a deeply stirring experience. The spiritual seemed everywhere in Ireland, immersed as we were in the beautiful and wild Irish landscape, looking at crumbling early monastery complexes like Glendalough, or beautifully carved standing high crosses, and, in Clonfert, once a thriving monastery center and pilgrimage destination, the unique west portal of St. Brendan's Cathedral, considered the finest example of twelfth-century carving in Ireland.

I remain open to the unexpected when we travel, be it art or something that suddenly happens in the natural world. Returning from Cesarta to Naples, Bill and I saw a brilliant double rainbow, silhouetted against a stormy sky as it hovered over nearby flat fields, hanging there for almost twenty minutes—more beautiful and rewarding than anything we had seen that day. On a cruise of the Greek islands we stopped at Mykonos, renowned for its whitewashed buildings and blazing blue skies. We walked into a small museum just before closing and saw an extraordinary object, a large early Greek earthenware pithos, dating from ca. 670 BC. It was decorated in relief with battle scenes from Homer's *Iliad,* which unfolded around the vase like some ancient Bayeux tapestry. Prominently positioned on its neck was the earliest known image of the Trojan horse, an astonishing visual translation. For two art historians so steeped in Neoclassical art, this was a moving discovery.

Years ago, we were in Paestum in southern Italy visiting the magnificent ancient Greek Doric temples. In the nearby museum is a tomb dating from ca. 480 BC with a removable roof or cover. The painted interior sides of this room-like tomb depict a symposium, the finest complete painting to survive from the archaic and classical Greek period, clearly indebted to Etruscan tomb painting. But what was most amazing was to see the graceful figure of a diver on the tomb's "ceiling," soaring through the air at the edge of the world, diving into the unknown of the afterlife.

Memories of travel sometimes become my way of being transported back in time, not only to where Bill and I were in our lives together, but also in a more meditative way to muse about cultural history and earlier civilizations, and to think about art and what propels us to create, and the need to bring order and connectiveness to everyday existence. Since my early years as an art history student, I have been drawn to the arts of the prehistoric and ancient world, which so often are objects for funerary use, gifts to the deceased or treasured objects to be brought forward into the afterlife.

There is a poignancy about funerary objects, both the commonplace and works of art and how they tell their owners' stories. Without them we would know so little about the history of ancient cultures. This was brought home to me not long ago when I saw an exceptional exhibition at the Metropolitan Museum, *Age of Empires: Chinese Art of the Qin and Han Dynasties, 221 BC to 220 AD,* which immersed me in a culture I knew nothing about. Beautifully installed, the exhibition presented an intellectually cogent view of a transformative period in China's history, when art became the instrument of creating a lasting cultural identity. Most of the objects were for funerary use, either used by the deceased while alive or created to replicate a life of luxury and power, including examples of the famous terracotta army buried to protect the first emperor of China. Also on display was an elaborate ceramic model of a Han mansion, miniature carriages, and a remarkable body suit of a Han princess, Dou Wan, made from two thousand jade tiles sewn together with gold thread. Small terracotta figures of court entertainers destined for royal tombs included an exquisitely robed female dancer with long sweeping sleeves whose performance was captured mid-movement, an early example of the elegance and refinement of Chinese art, remarkably preserved for posterity.

Recently, while in the Egyptian Museum in Turin, I saw the tomb of Kha, overseer of construction of the royal tombs, and his wife, Merit. Dating from circa 1500 to 1400 BC, its contents were hermetically sealed until their discovery in 1906. There before me was the Egyptians' absolute belief in the afterlife: beautifully painted sarcophagi with a large eye placed on either side, so the deceased could see the preparations for the afterlife, as well as finely decorated examples of the Book of the Dead to guide them on their journey. In the tomb was everything needed for the passage to the afterlife, including tunics and undergarments for different seasons; sheets and blankets; furniture, including elaborate beds; and also Merit's wig, jewelry, and cosmetic jars along with games, hunting and writing tools, and even perfectly preserved food, including salted duck, fruit, loaves of bread, and seeds.

As I looked at some of these objects, I thought about this memoir and enduring hearts; how the ancient Egyptians believed the heart harbored the mind and the soul and was the seat of intention and emotion. It was often left in the body, essential for the passage to the afterlife. I thought about how my own heart and intuition have guided me so surely, and how the way I "see" art relates not only to my eye but also to my heart, my capacity for empathy.

I think about what I have written and its meaning in the future, how I wanted to preserve my parents' memory and tell a portion of my own story, to keep it alive and meaningful. Is this my version of an "artifact" intended for a kind of afterlife, a human endeavor filled with memories and knowledge to be carried forward? Does it exist with those few "precious" objects that I treasure, that can mean so much to each of us, like my grandmother's fish dishes or my grandfather's Elijah goblet or our early nineteenth-century grandfather clock that Bill's grandfather lovingly restored.

I also think about those photographs in the attic I stopped to look at so carefully over a decade ago, and how they so profoundly moved me and slowly unlocked memories, helping me better understand my life's journey. For now, I hold my camera close, hoping to capture new memories for my grandchildren.

Acknowledgments

This journey has been painful, surprising, and revelatory, a gift of understanding of my life that I stumbled upon that fateful day when images of my grandparents and my parents in their youth suddenly unlocked memories of my childhood. It was an unexpected gift to be able to connect back emotionally with my father, to remember, and understand for the first time, in my seventies, just how much I am my father's daughter.

I am grateful to my many friends and family members who were generous with their time and who so thoughtfully pondered the many questions I posed to them. I especially want to thank Sandra Brown, Linda Field, Sally Tyler, Joanne Bailey, Art Warren, and Jennifer Strychasz, as well as my niece, Colleen Dorfman Saar, and my cousins Maxine and her late husband Fred Davine, Claire Koshar, Patty Paikin, and Allen Freedman. Linda read the entire manuscript and Sandra Brown an early draft. Their encouragement and insights were invaluable, and I will always be grateful for their generosity. Thanks also to my neighbors, Sabrina and Chris Johnson and Heather Gulesserian, who patiently listen to me talk about this project over drinks and neighborly chats. I also wish to thank my friend Temme Leeds-Barkin, with whom I have shared ideas about creativity and art.

I want to thank my editor, Kate Moses, for her sensitive reading of a draft of the manuscript and for her helpful suggestions. I would also like to thank She Writes Press and its publisher, Brooke Warner, as well as my project manager, Shannon Green, who has been a pleasure to work with. It has been illuminating, encouraging, and great fun to be part of the SWP secret authors group. I am delighted that Caitlin Hamilton Marketing & Publicity will steer media efforts.

My loving thanks go to my family in so many ways: to my brother-in-law, Paul Pressly, and his wife, Jane, for their enthusiasm, encouragement, and love and for answering so many questions about the past; to my son, David, for his careful reading of the manuscript and many helpful suggestions and for his patience and understanding as I told parts of my story; and to Pearl and Seymour Moskowitz for their support, their astute insights, and for becoming part of my family so many decades ago.

My deepest debt of gratitude is saved for my husband for his unwavering encouragement and support and his belief in this project. In my moments of doubt, he constantly reminded me of its importance not only for future generations but also because he believed I had a moving story to share with a larger audience. He generously has read several drafts, always making important suggestions; I have greatly benefited from his expert editing. Most importantly, I am so grateful we rode the crazy roller coaster of our lives together. We shared our love of art and experienced moments of spirituality and aesthetic pleasure that deeply moved us and which we might not have experienced so powerfully on own.

Lastly, I want to thank my beloved grandchildren, William Laurens and Caitlin Elizabeth Pressly, for being the amazing, kind, thoughtful, compassionate, imaginative, and loving children they are. I want them always to know how much I love them and that they have brought me such happiness.

About the Author

Nancy L. Pressly, a graduate of Goucher College, received her master's degree in art history from Columbia University. Beginning her career at the Metropolitan Museum of Art, she subsequently held curatorial positions at the Yale Center for British Art and the San Antonio Museum of Art. For nine years, she served as assistant director of the Museum Program at the National Endowment for the Arts before founding Nancy L. Pressly & Associates, a nationally recognized consulting firm specializing in strategic planning for art museums. Pressly has authored numerous publications, most recently a book titled *Settling the South Carolina Backcountry*. She and her husband live in Atlanta, Georgia, close to their son and two grandchildren, and travel extensively. She is an avid gardener and cook, a cat lover, and most recently has taken up throwing pottery.

Author photo © Atlanta Portrait Photography

Praise for *Unlocking*

"Pressly weaves a compelling memoir, revealing a history that extends across generations and time. Elegantly composed, *Unlocking* shares a deeply personal evolution. Pressly's story exemplifies the professional and personal challenges so many women confront, while showing how beauty and love can redeem those struggles."
—STEPHANIE HEYDT, Margaret and Terry Stent Curator of America Art, High Museum of Art

"In this clairvoyant and heartwarming memoir, Nancy L. Pressly shares her arduous path through the thickets of memory to reveal a remarkable and uplifting account of a woman who defined herself through positive energy and love. Guided by an agile intelligence and an eye for detail, honed by years in art history as scholar, curator, and consultant, Pressly animates memories long obscured by disappointments and losses. She makes the intensely personal universally compelling. We learn from her story how we might tackle the labyrinth of our own paradoxes."
—JUNE HARGROVE, author of *Paul Gauguin (1848-1903)* and recipient of the Chevalier of the Order of Arts and Letters

"In this memoir, Nancy Pressly shares a lifetime of intense experiences. Her extraordinarily careful and evocative descriptions of personal relationships, works of art, and places enrich this powerful autobiographical essay. Definitely worth reading more than once!"
—ELLEN G. MILES, art historian and author

"Nancy Pressly's revealing personal journey is a powerful inspiration. Uncovering childhood memories and family history, battling physical challenges, acknowledging and owning the roles of wife and mother, researcher, and accomplished arts administrator—all underscore a passionate life hard-earned and well-lived. Artfully written, her life story is a compassionate reminder of the power within to remain positive through adversity and obstacles, to stay true to oneself, and, above all, to embrace love of art, self, and family."
—ANDREA SNYDER, cofounder/codirector of American Dance Abroad and former assistant director of NEA Dance Program

Selected Titles from She Writes Press

She Writes Press is an independent publishing company founded to serve women writers everywhere. Visit us at www.shewritespress.com.

Lost Without the River: A Memoir by Barbara Hoffbeck Scoblic. $16.95, 978-1-63152-531-5. The story of a girl who grows up, leaves home, and eventually comes back again, Scoblic's memoir demonstrates the emotional power that even the smallest place can exert, and the gravitational pull that calls a person back home.

The Beauty of What Remains: Family Lost, Family Found by Susan Johnson Hadler. $16.95, 978-1-63152-007-5. Susan Johnson Hadler goes on a quest to find out who the missing people in her family were—and what happened to them—and succeeds in reuniting a family shattered for four generations.

All the Ghosts Dance Free: A Memoir by Terry Cameron Baldwin. $16.95, 978-1-63152-822-4. A poetic memoir that explores the legacy of alcoholism and teen suicide in one woman's life—and her efforts to create an authentic existence in the face of that legacy.

The Butterfly Groove: A Mother's Mystery, A Daughter's Journey by Jessica Barraco. $16.95, 978-1-63152-800-2. In an attempt to solve the mystery of her deceased mother's life, Jessica Barraco retraces the older woman's steps nearly forty years earlier—and finds herself along the way.

The S Word by Paolina Milana. $16.95, 978-1-63152-927-6. An insider's account of growing up with a schizophrenic mother, and the disastrous toll the illness—and her Sicilian Catholic family's code of secrecy—takes upon her young life.

The Sportscaster's Daughter: A Memoir by Cindi Michael. $16.95, 978-1-63152-107-2. Despite being disowned by her father—sportscaster George Michael, said to be the man who inspired ESPN's SportsCenter—Cindi Michael manages financially and heals emotionally, ultimately finding confidence from within.